IMAGES
of America

SIX FLAGS
OVER GEORGIA

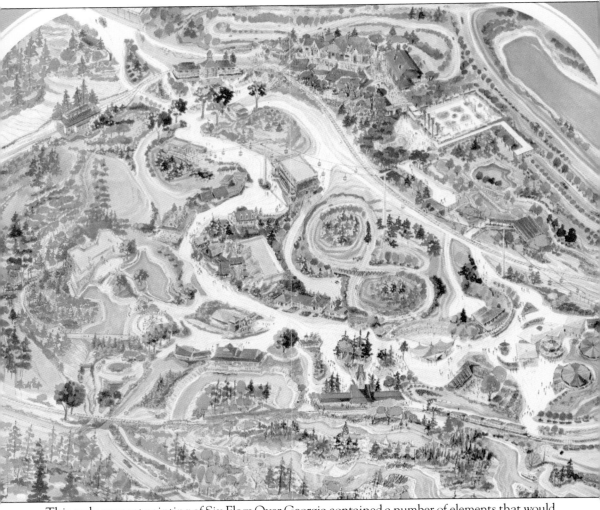

This early concept painting of Six Flags Over Georgia contained a number of elements that would not make it into the final version of the park, such as the two lakes near Castillo DeSoto and the re-created plantation in the center of the property. It also appears that the porpoise pool was originally supposed to be placed in the U.S.A. section. Other elements that were present on opening day, such as the Krofft Puppet Theater, do not appear in this artwork. (Author's collection.)

ON THE COVER: The Dahlonega Mine Train ride was the nearest thing to a roller coaster at Six Flags for the first six years. It was named in honor of the small Dahlonega community of northern Georgia, where gold was discovered in 1828. (Author's collection.)

IMAGES
of America

SIX FLAGS
OVER GEORGIA

Tim Hollis

ARCADIA
PUBLISHING

Copyright © 2006 by Tim Hollis
ISBN 978-0-7385-4358-1

Published by Arcadia Publishing
Charleston, South Carolina

Printed in the United States of America

Library of Congress Catalog Card Number: 2006930823

For all general information contact Arcadia Publishing at:
Telephone 843-853-2070
Fax 843-853-0044
E-mail sales@arcadiapublishing.com
For customer service and orders:
Toll-Free 1-888-313-2665

Visit us on the Internet at www.arcadiapublishing.com

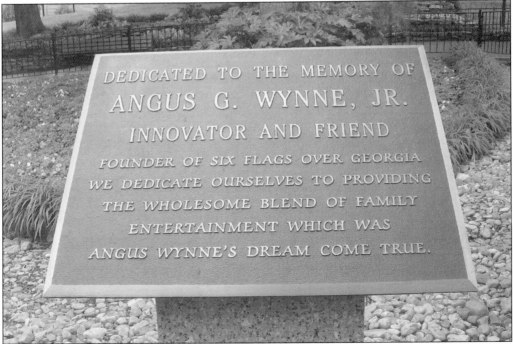

The invaluable contributions made by Six Flags founder Angus G. Wynne Jr. are suitably
acknowledged with this bronze plaque in one of the park's flower beds. (Author's collection.)

CONTENTS

ACKNOWLEDGMENTS

Pulling the material for this book together involved many different people, considering the fact that Six Flags' own archives have become scattered throughout various homes and offices over the years—and even at that, some of the material known to have existed has still not turned up. However, for their invaluable help in locating and identifying historic photographs and pieces of information, we should credit the following past and present employees of Six Flags Over Georgia: Bob Armstrong, Melinda Ashcraft, Kathy Bennett, Rick Boozer, Nelson Boyd, Steve Brodsky, Bob Cowhig, Don Daniel, Andy Duckett, Manuel Fernandez, Thom Fountain, Sherry Garner, Gary Goddard, John Hardman, Ryan Kilpatrick, Carl Marquardt, Errol McKoy, Johnny Milteer, Wayne Mings, Fred Moon, Roy Moore, Larry Nikolai, Gene Patrick, Christy Poore, Spurgeon Richardson, Cleveland Smith, Marcie Tanner, Jim Taylor, Jon Trewhitt, Bryant Upchurch, Wayne Vansant, Tom Wood, and David Wynne.

There are times when corporate archives are not enough, and historic preservation falls to collectors and tourists who visited the park and cared enough about it to preserve photographs, souvenirs, and other memorabilia. Among those hardy souls whose pack-rat habits helped enliven this book were Dan Alexander, Rod Bennett, Chris Burdett, Karen Clark, Shaunnon Drake, Jim Futrell, Dan Goodsell, Scott Jordan, Davis McCown, Chris Merritt, Wayne Neuwirth, Donnie Pitchford, and Jon Waterhouse.

INTRODUCTION

Before Georgia, there was Texas.

No, we are not talking about in a literal sense—although there would probably be plenty of Texans ready to agree to the claim. However, in the more narrow aspect of Six Flags Over Georgia, it is safe to say that it would not have come into existence had it not been for its predecessor in the Lone Star State.

In 1961, real-estate developer Angus Wynne Jr. opened his Six Flags Over Texas theme park midway between Dallas and Fort Worth. Wynne was admittedly inspired by the success of Disneyland, which had been attracting tourists (not to mention talking mice and flying elephants) to Anaheim, California, since 1955. Wynne had a strong feeling that similar parks could be successful in other parts of the country, even if necessarily done on a smaller scale. For his first park, he chose to model the various sections after the six national flags that had flown over the state: Spain, Mexico, France, the Confederacy, the Republic of Texas, and the United States. Originally he was going to call his park Texas Under Six Flags, but his wife soon reminded him that Texans would get plumb riled if anyone suggested their state had ever been "under" anything. The compromise was Six Flags Over Texas, although the linguistic difference between being under six flags and having the six flags over the state is somewhat of a moot point to those who do not live there.

Wynne's son David elaborates on just how the original Six Flags park began: "Six Flags Over Texas was created to generate cash flow for Great Southwest Corporation's 8,000-acre industrial park. It was the largest planned industrial park in the nation, but had stalled in 1960, ahead of its time. Many of the items in the park were purchased from the defunct Freedomland in the Bronx. William Zeckendorf, the legendary head of Webb and Knapp, who had taken a beating on Freedomland, actually planted the seed of a similar facility, done right, in Arlington. Dad looked at Webb and Knapp's unfortunate experience with Freedomland, as a 'how-not-to' gauge for what he was planning."

It was not long after the Texas park was up and running that Wynne began looking for a second location. He eyed the Southeast as fertile soil, probably unaware that Walt Disney was covertly buying up vast acreage in Central Florida with the same intent. In the *Wall Street Journal* of August 17, 1965, a news item with a Dallas dateline revealed that the Great Southwest Corporation and Angus Wynne Jr. had announced the purchase of 3,000 acres near Atlanta, with plans to develop the property into a $400-million industrial district and amusement center. The amusement park, not surprisingly, was expected to be similar to Six Flags Over Texas, but at that early date its eventual theme and name had not yet been selected. The park was slated to open in 1967 after an investment of some $7 million.

It is somewhat amazing, in hindsight, to see that apparently there was no original plan to duplicate the Six Flags name in Georgia. Instead, the first architectural renderings for the proposed park called it "Georgia Flags." One probable reason for this is that, while six flags were selected to represent the various areas of the Atlanta park, the fact is that Georgia has not necessarily been

under the flags of six separate countries in the same way Texas has. Spain, France, the Confederacy, and the United States would remain; however, Mexico surrendered to Britain (which had never had a stake in Texas), and most obviously, the Republic of Texas was replaced by the Georgia state flag. This is where the total actually came up short, as the Georgia flag never represented an independent nation as the Texas one did, but it all made little difference in the end. By the time the park opened on June 16, 1967, the cost had ballooned to $12 million, and the park was known as Six Flags Over Georgia.

Whereas the Disney theme parks were laid out in such a way that everyone had to enter via Main Street U.S.A. and then branch out to the various "lands" from a central hub, Six Flags Over Georgia was designed in a more circular fashion. Although each visitor had his or her own preferred plan for touring the park, the general flow of traffic seemed to indicate that the majority turned right from the entrance mall and proceeded around the park in a counterclockwise direction. This style of theme-park design has been designated the "Duell loop," after former Hollywood art director Randall Duell, who popularized it through his work with the Six Flags parks and others as well.

Now that we have our car situated in the vast parking lot, let's hop aboard one of the trams that wait to transport us to the front gate. Here it comes now . . . get ready to experience the history of Georgia and the Southeast as interpreted by owners from Texas and designers from California. Don't be shocked if we encounter a few surprises along the way!

Lurking somewhere behind those oversized sunglasses is the author of this book, as seen during his first visit to Six Flags in August 1967, two months after the park's opening. (Author's collection.)

One

Six Flags over Yesterday

Prior to the start of construction, the property where Six Flags Over Georgia now sits was a portion of a large family-owned dairy farm. In fact, to this day, some of the farm's original structures are still standing behind the scenes and used for storage and administrative purposes. After much work, the rest of the terrain was transformed into six themed areas representing the various eras in the history of Georgia (and the rest of the South).

In many ways, it almost seems as if Six Flags' first season was a sort of trial balloon to see what was going to float with the public. Many elements of the park were changed or replaced before the beginning of the 1968 season, including the facade of the Krofft Puppet Theater and almost the entire interior of the Tales of the Okefenokee dark ride. The park's antebellum-styled music hall, referred to in opening-day publicity as the Athenaeum, became the easier-to-pronounce Crystal Pistol.

One of Angus Wynne's innovations, which he instituted in Texas and then continued in Georgia, was the single-admission ticket. Even at Disneyland in the early days, guests had to reach into their pockets each time they wanted to sample a different attraction, and Wynne could see that psychologically that was not such a good idea. At the Six Flags parks, the admission price ($3.95 on opening day in Georgia) entitled one to all of the various rides and shows, with only food and souvenirs costing anything extra.

Another innovation had less influence on theme parks in the future. After visiting Six Flags during its press preview period, one newspaper writer commented, "It is the best of old Georgia. But it also has something that is even better than the new Georgia: overhead units blow air-conditioned coolness on persons wandering down the paths or waiting in line for the attractions." Many ideas worked, but outdoor air-conditioning was apparently not one of them.

In this first section, we are going to take our time machine back to 1967 and see how the park's early publicity attempted to educate people as to just what this thing called a "theme park" really was. We will then make our way through the park's assorted sections. Put on your comfortable walking shoes and step this way!

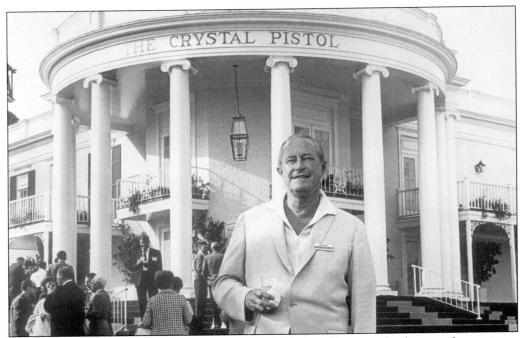

Texas businessman Angus G. Wynne Jr. had the radical idea of bringing the theme park experience to areas of the country where such entertainment was unknown. He opened Six Flags Over Texas in 1961 and soon thereafter began planning a second park in Georgia. (Nelson Boyd collection.)

Randall Duell's original proposal for the Atlanta park did not use the Six Flags name, supposedly due to the fact that the state had not technically been under the flags of six separate sovereign nations, as Texas had. (Scott Jordan collection.)

Artist Hans Peters was responsible for the look of Six Flags Over Georgia. His career as a Hollywood art director dated back to the 1930s, and he had worked on movies as diverse as *Heidi* (with Shirley Temple), *The Adventures of Sherlock Holmes* (with Basil Rathbone and Nigel Bruce), and *So This Is Washington* (with radio stars Lum and Abner). (Manuel Fernandez collection.)

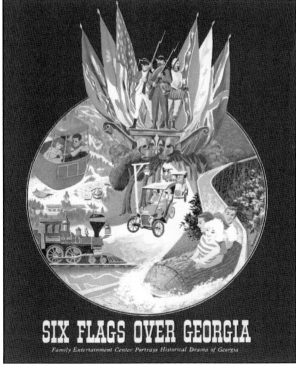

This stunning artwork was created to promote Six Flags' upcoming opening on June 16, 1967. It did a marvelous job of alerting magazine readers to the main features of the new park. (Author's collection.)

SIX FLAGS BUGLER

"Trumpeting the News of Georgia Since 1540"

Publication of Six Flags Over Georgia / I-20 West / Atlanta

"SIX FLAGS" UNFURLS JUNE 16!

THE DRAMA OF GEORGIA.

★

Rich In History.

★

SIX BANNERS INFLUENCED HER.

★

Almost 200 years before Gen. James Oglethorpe began to settle Georgia's eastern coast, the famed Spaniard, Hernando de Soto, led a daring expedition across Georgia from the state's southwestern corner to the Atlantic Ocean.

The year was 1540. For almost 250 years thereafter, England, France, and Spain were contestants for the rich and varied land that still bears the name of an English king But even before de Soto came, the Indians of various tribes dominated Georgia and had to be reckoned with in any nation's plan for conquest.

Oglethorpe

Thus, Georgia was always highly prized for her natural riches. Areas of the state changed hands repeatedly but with the royal charter given to Oglethorpe in 1732, the land—called by some Englishmen the "Garden of Eden"—increasingly came under English domination.

The Revolutionary War brought colonial status—and a new flag to Georgia. But less than a century later, Georgia's own flag flew with that of a new nation, the Confederate States.

But for more than 100 years now, Georgians have proudly flown the flag of a united nation, the sixth flag to float over a land of great mystery, great enchantment, and rich history.

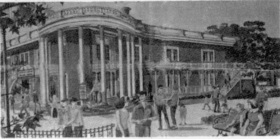

THE ATHENEUM, "SIX FLAGS" EXCITING MUSIC HALL

A CAST OF CHARACTERS!

The history of Georgia is laced with enough exciting events and unusual characters to fill thousands of books.

And when you come to "Six Flags Over Georgia," you'll be reminded of many of them, for some of the names are recalled as are their deeds.

For the time being, test yourself on what YOU know about Georgia's amazing past. Here's a brief quiz of 12 questions, and clues to each answer.

After you pair the clues and the answers, check your results with the answers in the "Quiz Box" on page four. No matter how many you get right, you're welcome to "Six Flags Over Georgia!"

1. De Soto crossed into Georgia near the present-day town of (a) Columbus (b) Bainbridge (c) West Point (d) Augusta.
2. The early Spanish name for all of Georgia was (a) Guale (b) Conquistador (c) Azilia (d) Barbacoa.
3. An early Indian tribe in Georgia was known as the (a) Shawnees (b) Piutes (c) Ute (d) Creeks.
4. An important Indian chief in

Georgia in the early 1700s was (a) Chief Bando (b) Emperor Brim (c) Sitting Bull (d) Chief Yamassee.

5. The British king who gave Oglethorpe a charter to settle Georgia was (a) George III (b) George II (c) Edward IV (d) Henry V.

Hernando de Soto

6. Oglethorpe's first camp in Georgia, near Savannah, was on a site called (a) James Hill (b) King George Mountain (c) Yamacraw Bluff (d) Augusta Heights.
7. Nancy Hart was (a) the wife of Tomochichi, an Indian chief (b) a Revolutionary War heroine in Georgia (c) the first child born at Oglethorpe's new settlement (d) an interpreter for Tomochichi.
8. Lyman Hall and George Walton were two of Georgia's three signers of the Declaration of Independence. The third man was (a) Franklin Thomas (b) Burton George (c) Henry Paine (d) Button Gwinnett.
9. The first president of the United States to visit Georgia was (a) Thomas Jefferson (b) John Adams (c) George Washington (d) James Madison.
10. By 1850, Georgia had—how many miles of railroad? (a) 5,-000 (b) 250 (c) 500 (d) 1,800.
11. Confederate President Jefferson Davis was captured in Georgia nearest one of these towns: (a) Dalton (b) Washington (c) Augusta (d) Columbus.
12. Atlanta officially became the capital of Georgia in (a) 1858 (b) 1850 (c) 1870 (d) 1877.

EXCITEMENT REIGNS!

★

Family Funfest!

★

RIDES GALORE IN HUGE PARK.

★

"Six Flags Over Georgia," a wonderland of the centuries, makes its fun-filled debut on June 16—and when you see it, you still won't believe it.

The $12,000,000 276-acre amusement park located a few minutes from downtown Atlanta, is a stunning creation fusing Georgia's rich, kaleidoscopic history with the kind of family fun offered nowhere else.

In a rolling nook of Cobb County, where men in Gray and Blue a century ago contested for every inch of ground, artists and architects have dreamed up a fantasyland filled with 75 rides, shows, and entertainment attractions.

It's already being hailed as Georgia's No. 1 tourist attraction, partly because that's what its forerunner, "Six Flags Over Texas," has meant to the Lone Star State.

Imagination is the golden vein which makes every inch of "Six Flags Over Georgia" glisten with sudden delights as you stroll the pin-clean grounds.

Within an hour—if you don't stop to enjoy all the attractions—you could whip through settings that recall the influences that the flags of six nations have wrought on Georgia history.

England, France, Spain, Georgia, the Confederacy, and the United States—all have left their imprint on the Empire State of the South. And the atmosphere

Continued On Page 4

This mock newspaper was sent out in advance of the grand opening to educate the public as to some of the historic epochs and more obscure personages to be represented in the park. (Six Flags collection.)

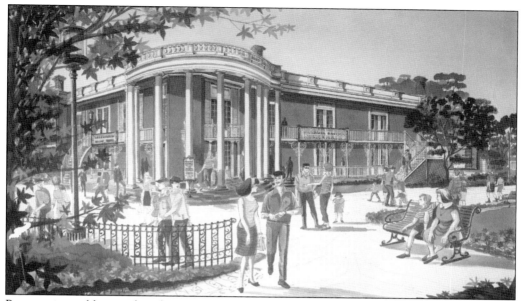

Pre-opening publicity referred to Six Flags' antebellum music hall as the Athenaeum and claimed it was modeled after a white-columned theater that opened near the Atlanta railroad station in the 1850s. You can see here that the theme park version closely resembled Hans Peters' original concept art, but the name was soon changed to the Crystal Pistol. (Carl Marquardt/Nelson Boyd collections.)

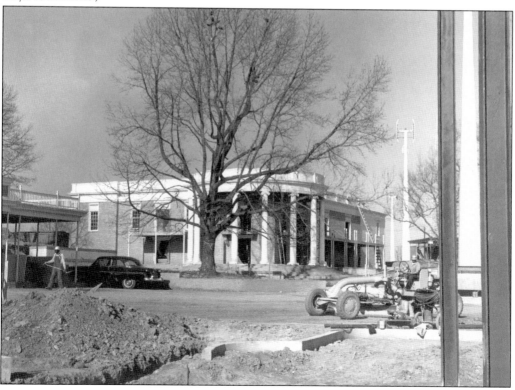

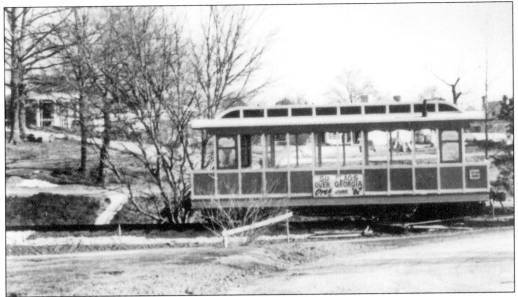

Down the hill from the Crystal Pistol, what would become one of the passenger cars of the Six Flags Railroad waits patiently, bedecked by a sign announcing the impending opening date. (Six Flags collection.)

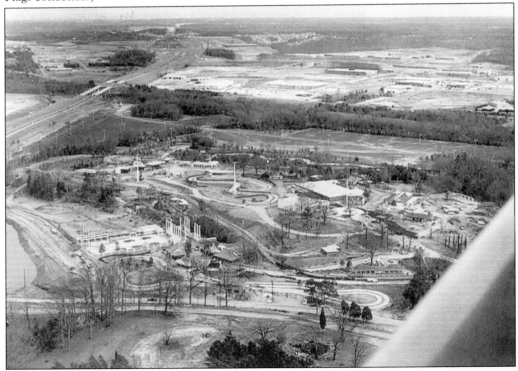

A photographer flew over the work-in-progress park, apparently during the winter of 1966–1967 judging from the lack of foliage on the trees. Notice that outside the gates, it appears that I-20 had a way to go before being completed, too. (Scott Jordan collection.)

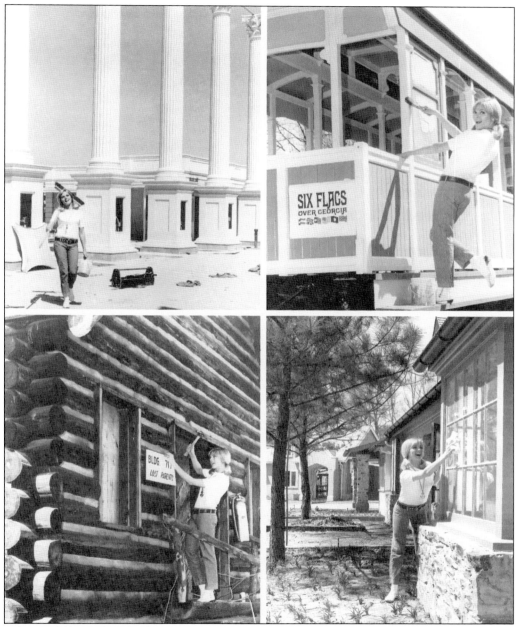

Who would have thought that one attractive young lady was responsible for building Six Flags all by herself? Prior to opening, the publicity department sent out this set of photographs of Georgia State University student Bonnie Dee Reeves apparently enjoying her solo job of getting the entire park ready for visitors. (Manuel Fernandez collection.)

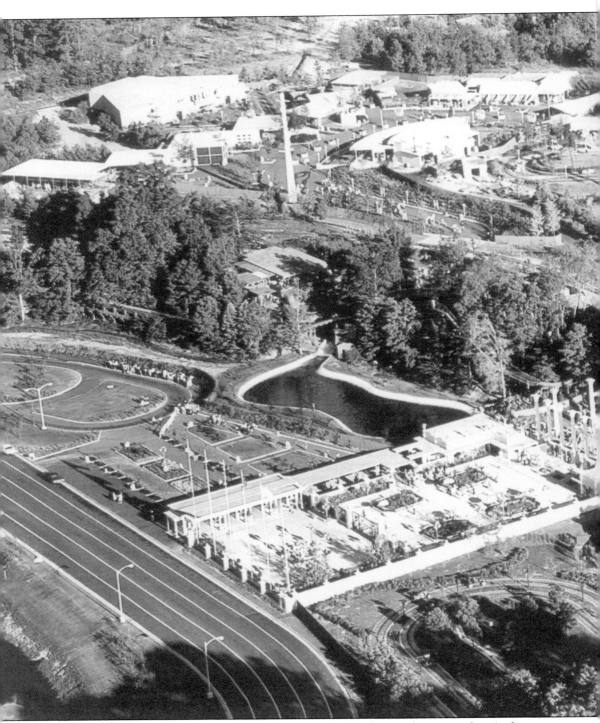

This spectacular view shows most of Six Flags as it appeared around opening day. At far upper left is the Krofft Puppet Theater, with its original circus-style facade that would be changed the following season. Shaped like a figure eight, the Happy Motoring Freeway dominates the center

of the park, and to the right are the large buildings housing the Crystal Pistol (or Athenaeum) music hall and the Tales of the Okefenokee dark ride. In the lower foreground, the Hanson antique cars putter around their quaint British neighborhood. (Nelson Boyd collection.)

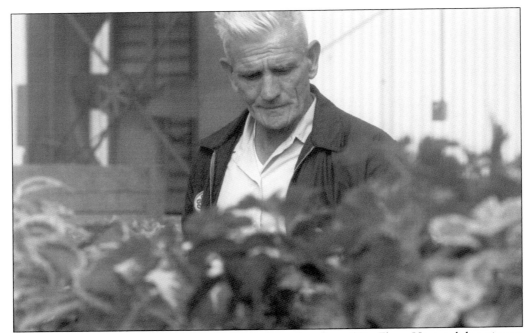

Frank Blackburn was instrumental in the overall landscaping of Six Flags. His total devotion to the park's many flowering gardens made him a beloved figure and a true park legend within his own time. "This job is my life," he once said, and no one doubted it. (Six Flags collection.)

Six Flags' trademark hanging baskets were considered such a novelty that the park eventually published a pamphlet instructing guests how to make their own for home decor. (Six Flags collection.)

Two

MARCHING THROUGH GEORGIA (AND BRITAIN)

Six Flags made good and certain that its visitors' first sight in the park would be one that set the stage for everything to follow. The entrance plaza, designated on the map by the official name Mall of the Six Flags, was a gleaming, spotless evocation of the grounds of a classic Southern plantation, with the addition of the titular six flags waving proudly in the breeze. White fountains, classical statuary, and magnificent columns abounded. A wackier element that could often be found around the entrance was the various costumed cartoon characters employed by the park, some old friends whom we shall visit in this chapter as well.

Adjoining the entrance mall on either side were the two sections of the park that had no previous counterparts at the parent Texas facility, the British and Georgia realms. With no rides other than the Hanson cars' landscaped grounds to pull pedestrians off the path, the British section had to rely on retail establishments to earn its keep. The main refreshment stop was given the following historical pedigree: "In Savannah, the American Revolutionaries erected a Liberty Pole in front of Peter Tondee's tavern to protest British authority and express defiance of the Stamp Act of 1765. Six Flags has a replica of the Liberty Pole and Tondee's Tavern to commemorate this significant location." The Six Flags version of Tondee's Tavern, however, specialized in hot dogs and hamburgers rather than steak and ale.

A less faithful usage of history was based upon the fact that early English settlers in Georgia were befriended by a Creek chief known as Emperor Brim. His moniker became the name of the British section's souvenir shop selling (what else?) decorative headgear. Other knickknacks could be purchased for a few pence (or a lot of pounds) in the Dickensian-named Curiosity Shop, while Piccadilly Sweets satisfied those needing a quick goody fix. A later addition was Old King Cole's Toy Store, which made everyone into a jolly old soul.

The Georgia section was even smaller than the British one but made up for that by being home to the Log Jamboree, the ride that virtually served as a Six Flags trademark in the early days. Six Flags Over Texas had the first log flume ride in amusement park history, so you could bet your Bunyan that it would be a major part of the Georgia park from the beginning.

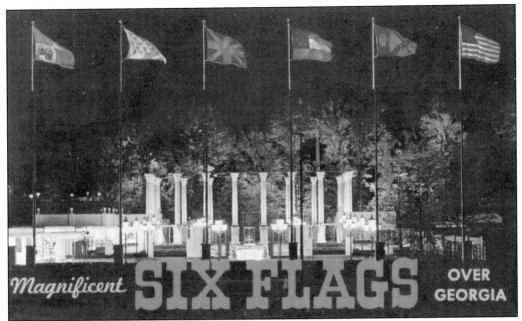

Magnificent SIX FLAGS OVER GEORGIA

As seen when approaching the park off I-20, the Mall of the Six Flags was an impressive sight at any time of the day, but especially when illuminated at night. The postcard company got it right when they chose the word "magnificent" for this image. (Author's collection.)

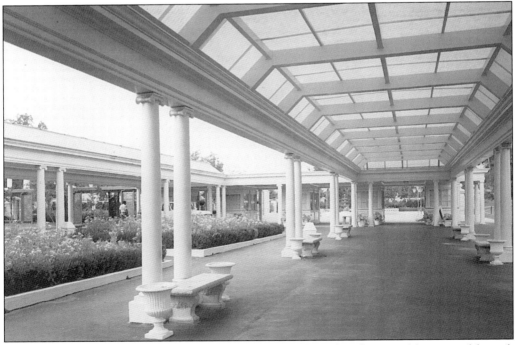

After disembarking from the trams that shuttled them from the parking lot, guests' first view of the park was this concourse, with its skylights leading toward the ticket booths. (Six Flags collection.)

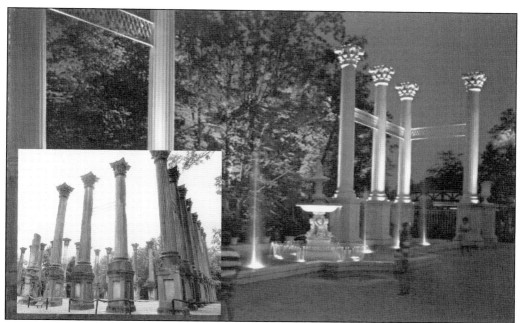

The white Corinthian columns that decorated Six Flags' entrance court were quite obviously modeled after the ruins of Windsor, a former plantation in southern Mississippi (seen in the inset photograph above). During a remodeling program in 1998, all but a few of the Six Flags columns were removed, and the area now serves as a "street" of shops and other amenities known as the Promenade. (Author's collection.)

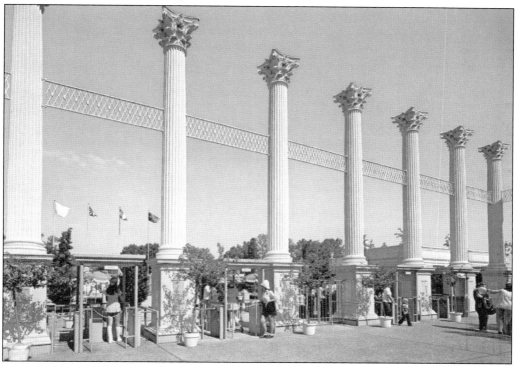

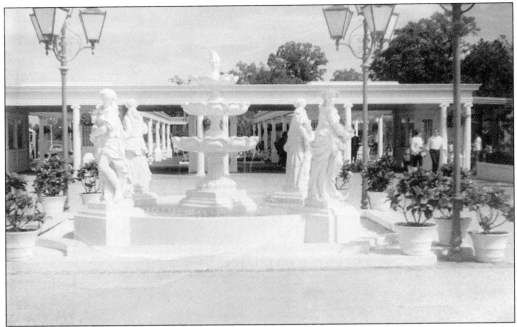

The entrance mall, with its columns, burbling fountains and classical statuary, was meant to evoke the ambiance of an elegant Southern plantation. Guests were immediately immersed in a world representative of Georgia's rich historical past. (Author's collection.)

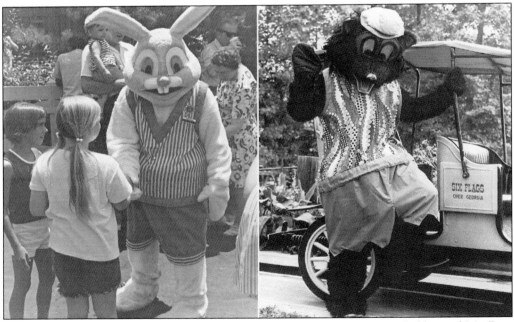

The first costumed characters to roam the park and greet guests were Mr. Rabbit and Mr. Bear from the Tales of the Okefenokee ride. Antisocial Mr. Fox declined to make nice with the visitors. (Six Flags collection.)

Puppeteers Sid and Marty Krofft were rapidly becoming famous for their Saturday morning television programming; in 1970, their star creation, H. R. Pufnstuf, made his debut as a Six Flags character. (Andy Duckett collection.)

Pufnstuf's sidekicks, Cling and Clang, must have been taking vitamins before moving from Living Island to Atlanta. On television, they were only four feet tall, but at Six Flags, they towered over most of the guests. (Andy Duckett collection.)

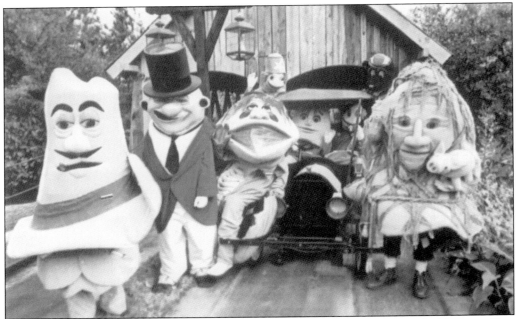

The Kroffts' television series *Lidsville* premiered in September 1971, and several of the series' hat characters were added to the Six Flags lineup for the 1972 operating season. Because the costumes were made by the park's own wardrobe department and not the Krofft studio, sometimes the characters came out looking slightly "off-model," giving them their own quirky charm. (Andy Duckett collection.)

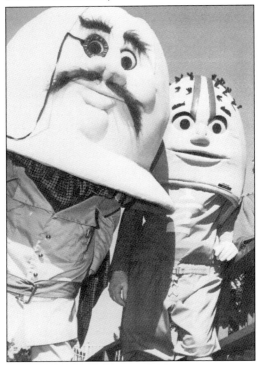

Colonel Poom the pith helmet and Rah Rah the football helmet were two more of the *Lidsville* characters the Six Flags costumers tried to duplicate. (Six Flags collection.)

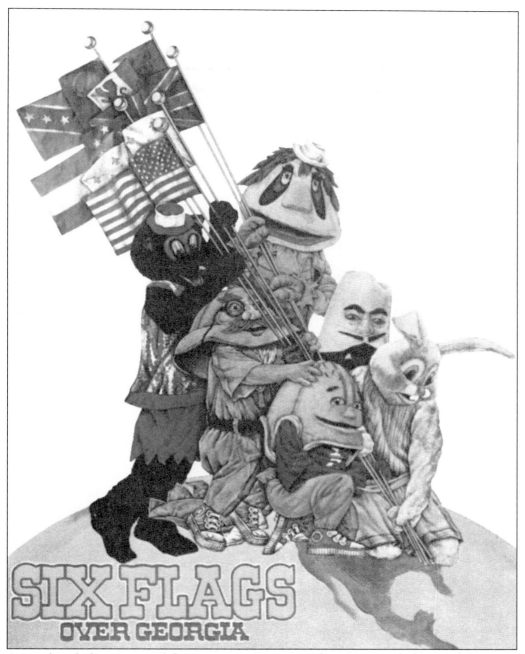

An unidentified artist created this amusing poster image of Mr. Bear, Mr. Rabbit, and the Krofft characters raising the six flags over the state of Georgia, Iwo Jima style. (Author's collection.)

When Six Flags began enlisting corporate sponsors in the early 1970s, several of the companies' related trademark characters began hanging out in the park. Here Mr. Rabbit (minus his head!) helps W. C. Fritos into his maroon jacket. (Andy Duckett collection.)

Domino Sugar was another of the companies that partnered with Six Flags, and their cuddly, bow-tied bear emblem roamed the property in 1972. (Chris Burdett collection.)

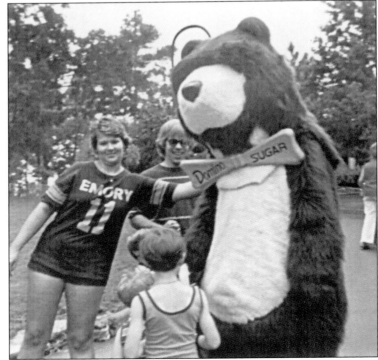

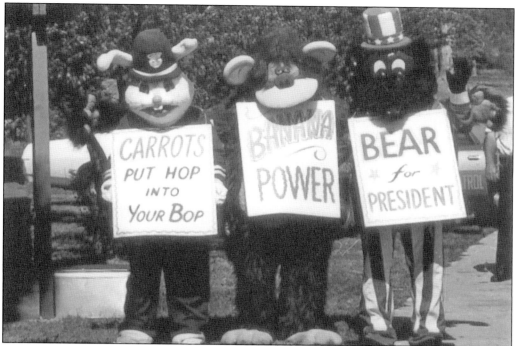

During the election year of 1976, several of the characters threw their hats into the campaign for president. Early returns indicated Mr. Rabbit was leading by a hare, the orangutan was monkeying around with foreign policy, and Mr. Bear's voters were all in hibernation. (Six Flags collection.)

When Quaker Oats joined the corporate sponsors in 1978, they sent that old seafarer Cap'n Crunch to prove he could stay crunchy, even in Georgia. (Bob Armstrong collection.)

As seen in its earliest days, Six Flags' British section resembled a quaint English street. In the center of the photograph, notice the framed poster that explained the British flag's role in Georgia history. A similar marker was installed in each of the six original sections of the park. (Six Flags collection.)

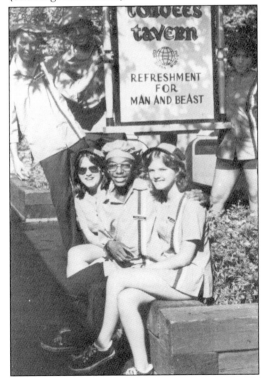

Tondee's Tavern was named after a real-life eatery that was a gathering place for revolutionaries in Savannah in 1765. . . . Those colonists had probably never seen skirts as short as these. (Bob Armstrong collection.)

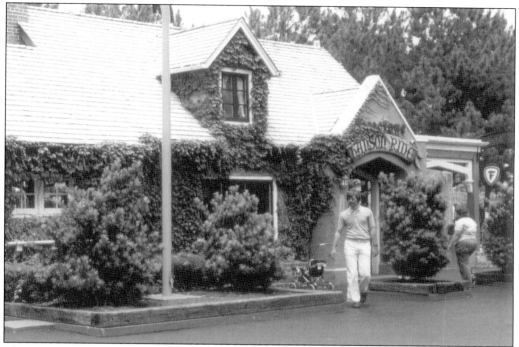

The Hanson antique car ride was one of the longest-surviving of the park's original 1967 attraction lineup. This building has been used as the entrance for the Georgia Cyclone roller coaster since the Hanson cars were moved to the area around Carousel Hill in 1990. (Andy Duckett collection.)

In keeping with the intention of tying everything in with some aspect of Georgia history, Six Flags noted that the Hanson automobile was manufactured in Atlanta from 1918 to 1925. Adults and children alike enjoyed piloting the simulated antique runabouts. (Author's collection.)

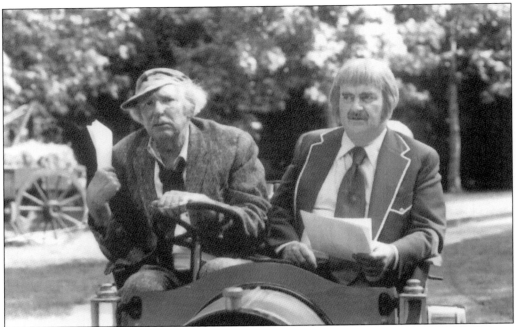

During their visit to Six Flags in 1976, Captain Kangaroo (Bob Keeshan, at right) and Mr. Bainter the Painter (Hugh Brannum, also known as Mr. Green Jeans) took a spin in a Hanson jalopy themselves. (Six Flags collection.)

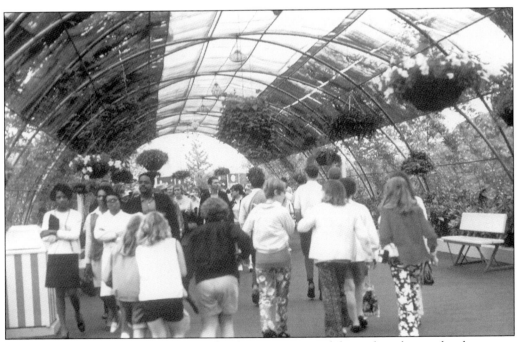

This shady arbor was the entrance to the Georgia section of the park and proved to be a most welcome sight on hot summer days. (Six Flags collection.)

After the world's first log flume ride was introduced at Six Flags Over Texas in 1963 and made such a splash, it was natural that the ride would be a part of the Georgia park. Named the Log Jamboree, it represented early Georgia's logging industry and was featured prominently in nearly every advertisement and souvenir for most of the park's first decade. (Author's collection.)

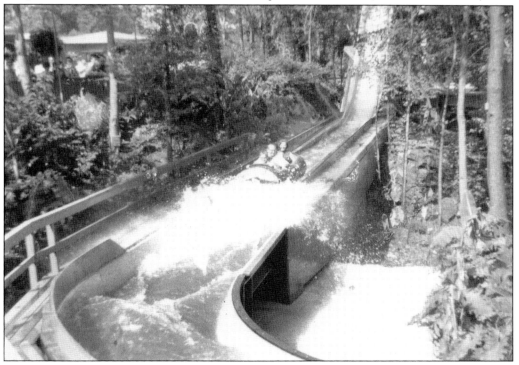

The original Log Jamboree was so popular that a second flume was added for the 1968 season. The two routes were entwined with each other, and Flume Number 2, as it was called, featured a final descent through this huge fiberglass log-shaped tunnel. (Carl Marquardt/Shaunnon Drake collections.)

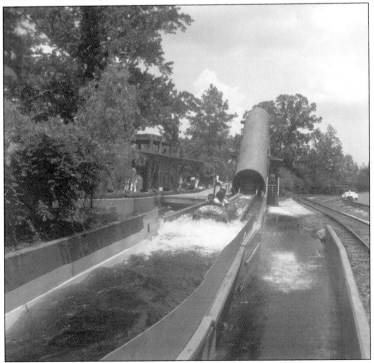

Flume Number 2 remains a popular attraction at Six Flags today, although the log tunnel was removed years ago. The original 1967 Flume Number 1 was razed in 1990 to make room for another water ride, Ragin' Rivers, which in turn gave way to the Georgia Scorcher roller coaster in 1998. (Six Flags collection.)

The talented team at Sid and Marty Krofft's headquarters built giant animated figures to enliven the two flume rides. On Flume Number 1, this dastardly villain laughed evilly and sawed away at a log that threatened to hit the boats passing below. (Six Flags collection.)

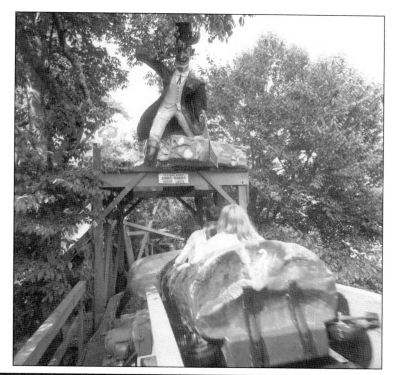

Flume Number 2 had a brutish Paul Bunyan look-alike who chopped at passing boats with his dreadful axe. Both figures were removed sometime around 1976. (Six Flags collection.)

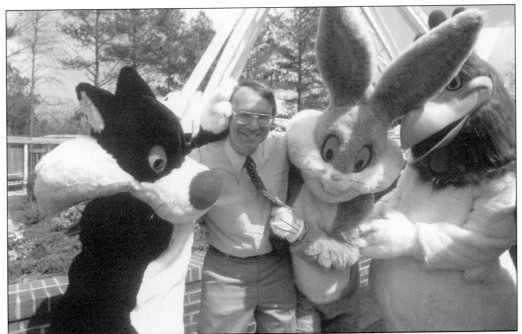

In 1985, Bugs Bunny and the other loony toons of Looney Tunes moved into Six Flags for a long stay. Here they demonstrate their patented brand of lunacy on general manager Spurgeon Richardson. (Six Flags collection.)

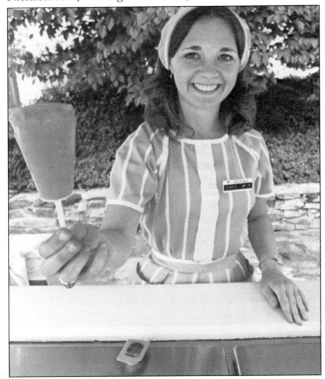

On a hot summer day in the early 1970s, nothing could be more refreshing than one of Six Flags' own Cherry Berry popsicles, with a surprise toy figure atop the stick inside. Thirty-five years later, there are collectors out there—this author included—who still have some of their Cherry Berry sticks. (Six Flags collection.)

Three

THE CONFEDERATE SECTION

Proceeding to the right after leaving the British section brought guests to the next themed area, the Confederate section. In stark contrast with the tiny, almost undeveloped British section, much love and attention appears to have been lavished on this antebellum world, making it the centerpiece of the park both stylistically and geographically.

Immediately upon making the transition into the Confederate theme, one of the first sights was the Marthasville depot of the Six Flags Railroad. Those who chose not to make a half-circuit around the park via the railroad would next encounter the Dahlonega Mine Train. The name came from the tiny Dahlonega community of north Georgia, where gold was discovered in 1828, setting off a short-lived rush.

Having passed up the earthbound Six Flags Railroad, those already in a hurry to be somewhere else could have a choice of two sky rides departing from the Confederate section within a few feet of each other. During Six Flags' first season, only one of these existed: the Sky Lift traveled back and forth to the U.S.A. section. With the 1968 addition of the Lickskillet section on the park's northern boundary, the Sky Buckets provided a shuttle to that replicated mining town. Today only the Confederate-Lickskillet Sky Buckets remain; the Confederate-U.S.A. Sky Lift was dismantled in 1981, and its stations were converted to other uses. The two sky rides crossed each other above the magnificent Crystal Pistol music hall.

The most elaborate attraction in the Confederate section was Tales of the Okefenokee, a dark ride through scenes from old plantation legends made famous by Atlanta author Joel Chandler Harris. After a lackluster first season, the imaginative staff of Sid and Marty Krofft refurbished the ride, and visitors enjoyed Mr. Rabbit's outwitting of Mr. Fox and Mr. Bear until the close of the 1980 season.

As with the other areas of the park, the Confederate section featured a variety of themed locales where visitors could fend off starvation or otherwise get rid of some of that money burning a hole in their pockets. Restaurants included the Black Friar, Auntie Bellum's Sandwich Shop, and Naler's Plantation, specializing in Southern fried chicken. Baskin-Robbins ice cream dished out its 31 flavors next door to the Okefenokee ride, and souvenirs of various other flavors could be purchased at Miss Abigail's Gift Shop and the Glad Hatter.

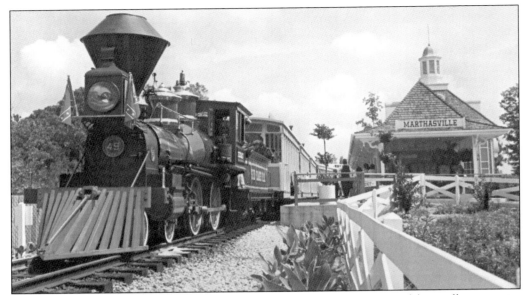

The Marthasville depot of the Six Flags Railroad was given the second name of the small community that would grow up to become Atlanta. The original name was Terminus, as the town was the end of the line for the Western and Atlantic Railroad. (Nelson Boyd collection.)

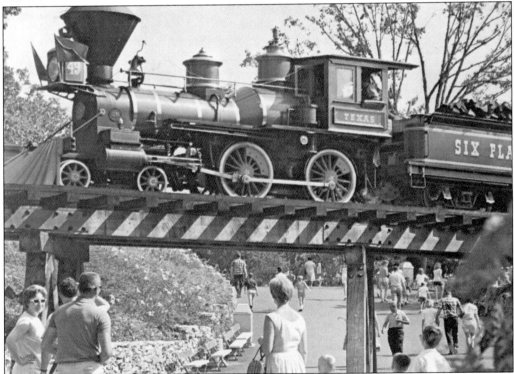

The *Texas* and the *General*, replicas of the engines that participated in the famed "great locomotive chase" during the Civil War, pursued each other around the Six Flags perimeter at a more leisurely pace. (Author's collection.)

When Six Flags opened in 1967, there was no need for guests to cross the tracks while getting around the park. Employees did, though, as most of the administrative offices were located outside the oval formed by the railroad. (Six Flags collection.)

The clock tower was a park landmark, but some people might have wondered what was underneath. The base of the tower was a rather nondescript building that served as the park's ice manufacturing plant. (Six Flags collection.)

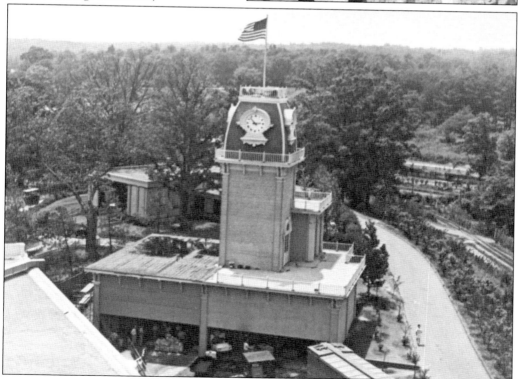

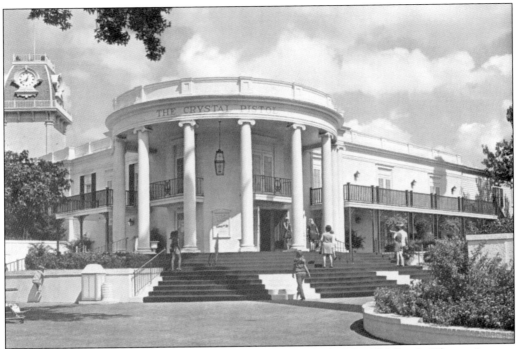

The very design of the Crystal Pistol music hall simply reeked of the Old South. The setting was enhanced by an artificial horse and buggy permanently parked at the side. (Author's collection.)

This photograph was likely taken just prior to the park's opening day; notice that the Crystal Pistol name had not yet been applied to the front of the portico. (Nelson Boyd collection.)

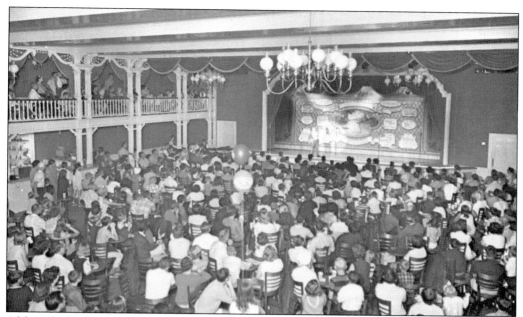

Although the live shows presented on the Crystal Pistol stage would later highlight patriotic, rock, and country music, in Six Flags' early seasons the offerings leaned more toward programs reminiscent of the vaudeville or even showboat eras. Many aspiring performers got their first show business break in these productions. (Wayne Neuwirth collection.)

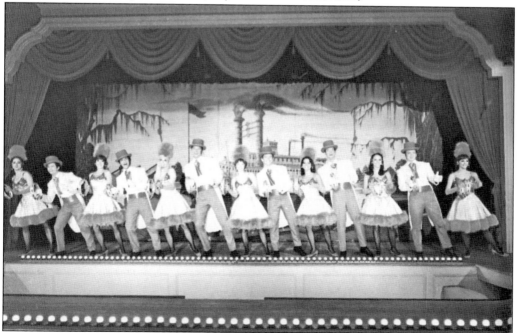

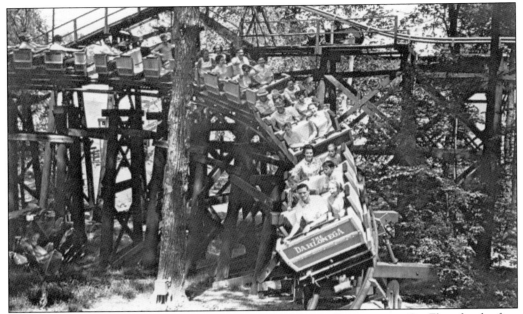

The Dahlonega Mine Train ride was the nearest thing to a roller coaster at Six Flags for the first six years. It continues to operate in the same spot today but with less surrounding forest than in this early photograph. (Author's collection.)

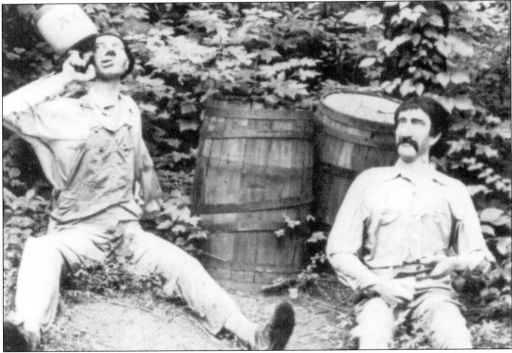

The Six Flags animation department populated the Mine Train landscaping with figures that included a washerwoman doing laundry, a prospector panning for gold, and these two moonshining mountaineers. (Bob Armstrong collection.)

The Mini-Mine Train, also known as the Yahoola Hooler (for reasons unknown), was installed in 1969 to give youngsters and nervous adults a bit of practice before tackling the full-fledged Dahlonega ride. (Andy Duckett collection.)

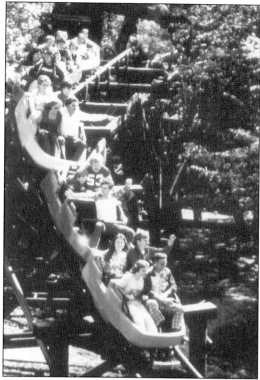

As performed by puppeteer Alan Cline, Buford Buzzard insulted all Six Flags visitors equally, regardless of gender, race, or creed, although he was particularly snide with visitors from Alabama. (Author's collection.)

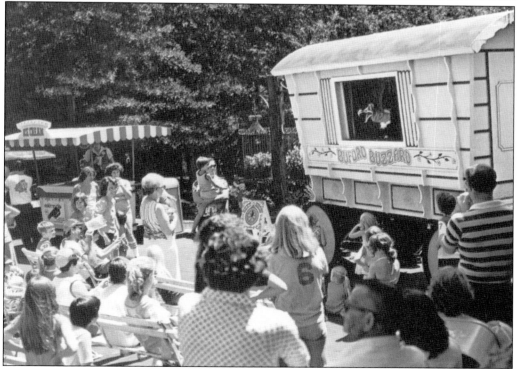

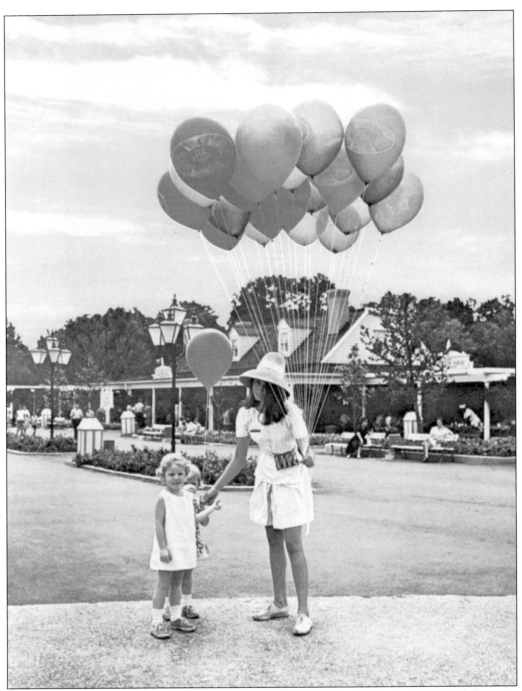

This classic publicity shot would be notable enough just because of the cute kids and the even cuter balloon seller, but behind all of them is the Naler's Plantation restaurant. Willis Naler had been a part of the Texas chain of Youngblood's Fried Chicken restaurants, and at Angus Wynne's urging, he went out on his own in 1961 to open his own outlets in each of the Six Flags parks. (Author's collection.)

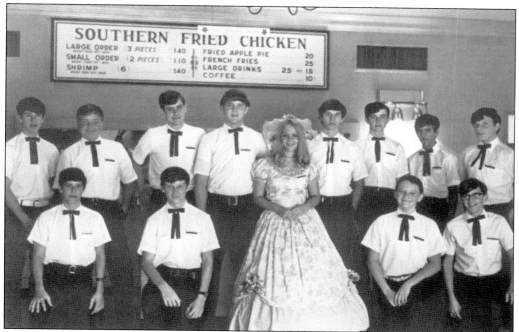

Employees and guests alike knew that Naler's was the place to go for delicious Southern fried chicken, but the prices on that menu board sure make it sound cheap, cheap, cheap! (Six Flags collection.)

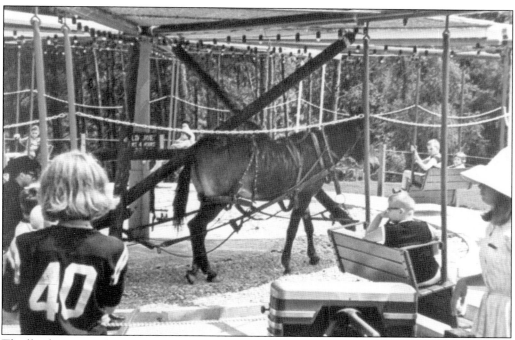

Thrill rides at Six Flags could be decidedly low-tech in the early days. Take the case of the Flying Jenny, also known as the Mule-Go-Round, a slow-moving set of swings powered by (surprise!) a live mule named Joe. (Author's collection.)

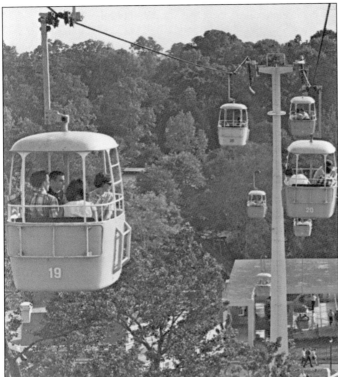

The multicolored buckets of the Sky Lift (also known as the Astrolift) transported guests from the antebellum world of the Confederate section to the modern-day trappings of the U.S.A. section. (Author's collection.)

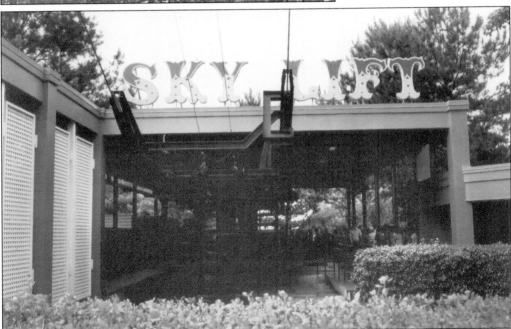

The original Confederate-U.S.A. Sky Lift was dismantled after the 1981 season. Its 12-ton counterweight, which was necessary for keeping the cable pulled taut, still rests in a pit underneath the Fearman's Manor haunted house attraction. (Andy Duckett collection.)

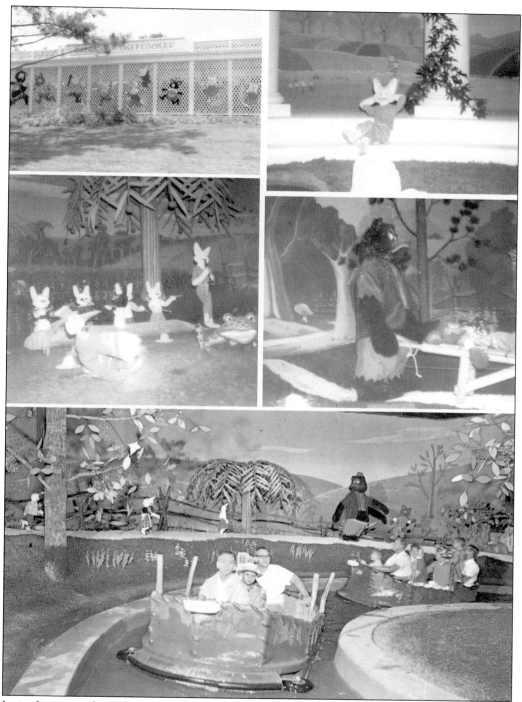

In its first year, the Tales of the Okefenokee ride looked completely different from the version most people remember (as seen in our next chapter). Photographs of the 1967 version are rare, but these show the original, tiny animated figures, the largest of which were only five feet tall. (Manuel Fernandez collection.)

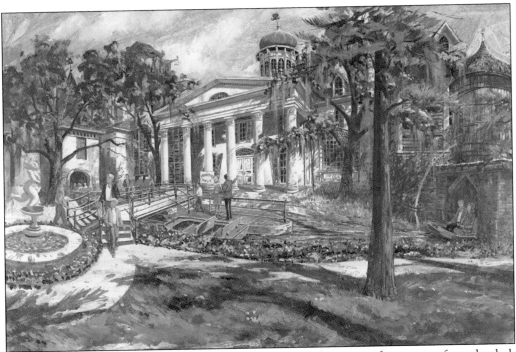

By the 1980 season, the Okefenokee was wearing out, and plans were afoot to transform the dark ride into the Monster Plantation. This was an early concept painting of how the new, creepy exterior might look. (Gary Goddard collection.)

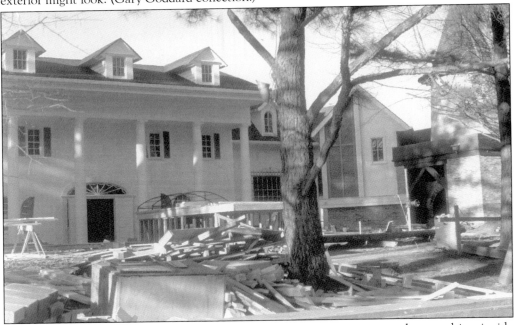

Over the winter of 1980–1981, the Okefenokee queue area was removed, everything inside the building was scrapped, and a new plantation-style facade was constructed in front. (Gary Goddard collection.)

Gary Goddard and his creative team in Los Angeles dreamed up the scenery and characters that would populate the Monster Plantation. Key players on the team were former Disney designer Al Bertino and cartoonist Phil Mendez. (Gary Goddard collection.)

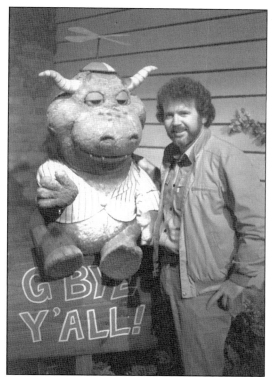

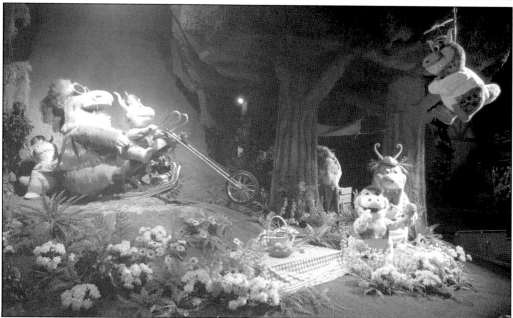

The trough in which the boats traveled remained the same, but otherwise everything else in the Monster Plantation was completely different from the ride's Okefenokee days. Jolly monsters frolicked along the riverbanks just as Mr. Rabbit, Mr. Fox, and Mr. Bear had done. (Gary Goddard collection.)

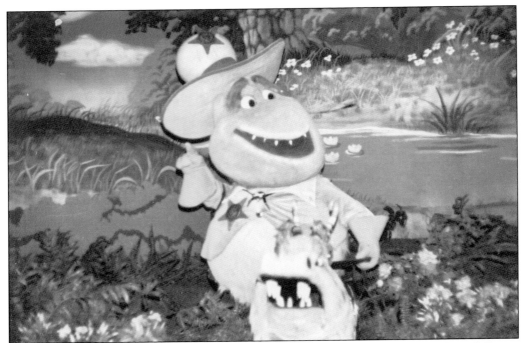

As boats float through the flooded grounds of the Monster Plantation, Marshal Billy Bob Fritter repeatedly shows up to warn visitors to "stay outta the marsh; that's baaaaad country out there!" Just our luck; wouldn't you know that is where we end up? (Author's collection.)

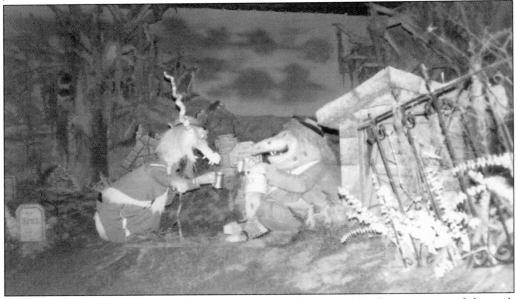

The tombstones in the Monster Plantation's graveyard scene paid tribute to many of the park executives and employees: "Here lies Nelson, gone to the Boyds" (Nelson Boyd, construction); "Ed" (Ed Frederickson, Boyd's assistant); "Errol, a real McKoy" (Errol McKoy, general manager); "General DeWitt" (Ned DeWitt, Six Flags Inc. president); and "Carl" (Carl Marquardt, maintenance foreman). (Author's collection.)

Four

TALES OF THE OKEFENOKEE

One of the most fondly remembered Six Flags attractions for the baby boomers who visited the park was the dark ride known as Tales of the Okefenokee. Dark rides dated back to the beginning of the 20th century, but the Okee (as it was familiarly known among park employees) definitely followed the later pattern established by the Disney parks. Propelled along a trough by the flow of the water, fiberglass boats passed through scenes from old plantation folk tales that were familiar to generations.

During Six Flags' first year of operation, the Okee was a totally different experience from the one most people remember. The original animated figures were quite tiny, and surviving film footage shows that their movements were rather awkward as well. Apparently almost as soon as the park opened, the company enlisted the help of Sid and Marty Krofft to redesign the Okee into a more satisfying experience.

The concept paintings for the new Okee were created by former Hanna-Barbera cartoon studio artist Art Lozzi. The Kroffts created all-new voice and music tracks for the ride, including a unifying theme melody that resonated in various musical styles through several of the scenes.

The storyline of the Okee ended happily, with Mr. Rabbit outfoxing his enemies Mr. Fox and Mr. Bear, but the ride itself met a grizzly fate. By the 1980 season, Six Flags felt that the jolly old swamp had overstayed its welcome, and plans were drawn up to convert it into a new dark ride known as the Monster Plantation. The trough in which the boats traveled remained unchanged, but everything else connected with the Okee was unceremoniously bulldozed and hauled off to the dump. The Monster Plantation made its debut at the beginning of the 1981 season and remains one of the most popular and unique features of Six Flags today.

In the following pages, we will re-create a trip through the Okefenokee in words and photographs. Wherever possible, actual photographs of the ride have been used; occasionally suitable photographs were simply not available, and in those cases we have substituted Art Lozzi's original concept paintings. Now let's "float down the river to the old plantation," as the theme song says.

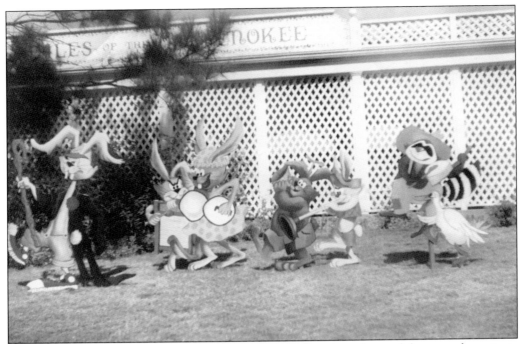

After the major redesign of the Okefenokee for 1968, the front lawn featured these wooden cutouts of the various characters, to better indicate what could be found inside. (Author's collection.)

As the boat approaches the dark entrance, these rabbits give some last-minute instructions before riders float into the multicolored foliage and Spanish moss hanging from the trees. (Author's collection.)

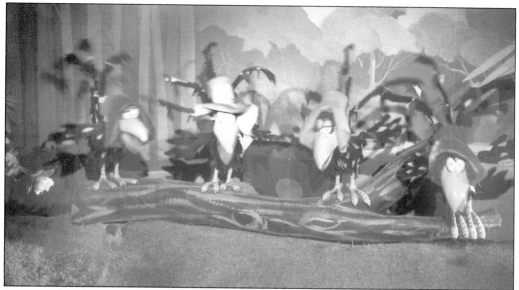

The first glimpse of life in the swamp is this quartet of hillbilly crows, who are in perfect harmony as they sing, "Welcome, neighbor, welcome to the Okefenokee/Welcome, neighbor, welcome, you shorely made our day!" (Six Flags collection.)

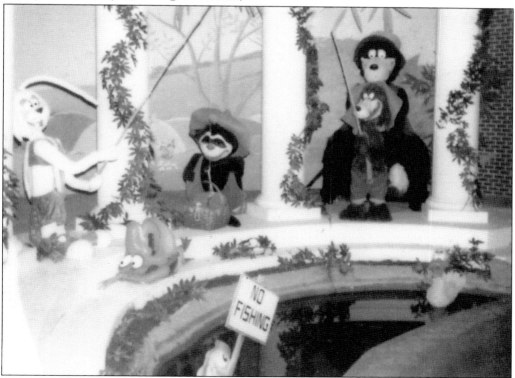

At the local fishing hole, apparently located in the ruins of a former plantation home, Mr. Rabbit tries to get a bite, while Mr. Fox and Mr. Bear would prefer to get a bite of Mr. Rabbit. A bullfrog works on his suntan while a raccoon fumbles with the picnic basket. (Manuel Fernandez collection.)

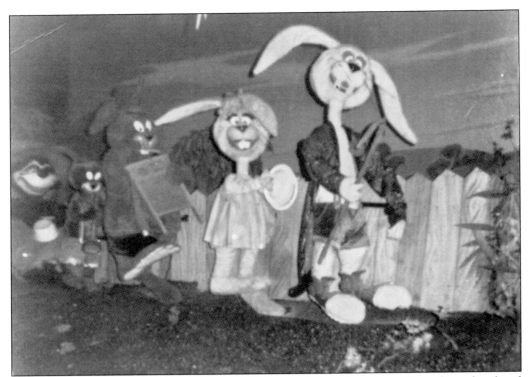

After passing through a tunnel, the vista opens up, and the critters have formed a gadget band with old Mr. Rabbit leading the way. It is not explained how a rabbit gets music out of blowing on a toilet plunger as if it were a trumpet. (Author's collection.)

Across the stream from the washboard band, a patch of lively carrots with Zsa Zsa Gabor faces sing out, "Save the rabbit! Save the rabbit! Whatever you do—or else he's gonna wind up as a kettle of stew!" Visitors soon find out what they mean. (Author's collection.)

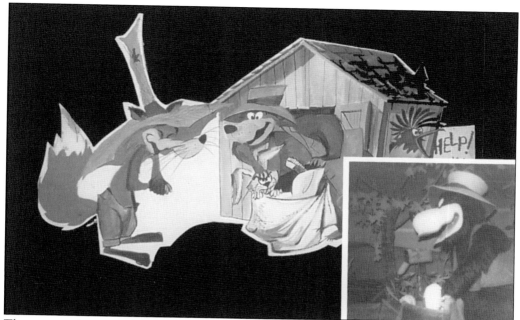

Those two miscreants, Mr. Fox and Mr. Bear, are stationed in front of the bear's ramshackle house, with the unfortunate Mr. Rabbit popping up and down inside their canvas sack. As Mr. Fox laughs evilly, a trapped chicken keeps poking its head out of the house's window to scream distractedly for help. (Dan Goodsell/Chris Burdett collections.)

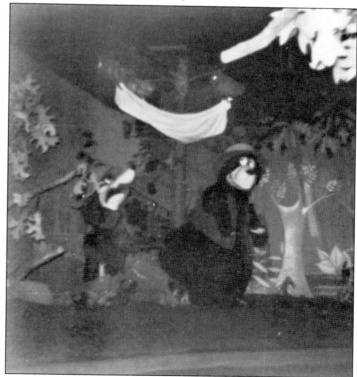

In the next clearing, Mr. Rabbit has been rescued by the friendly owls, who have rigged up a sheet as a convincing simulation of a ghost. The fox and bear are plainly terrified and are cringing at the very sight of the apparition. (Author's collection.)

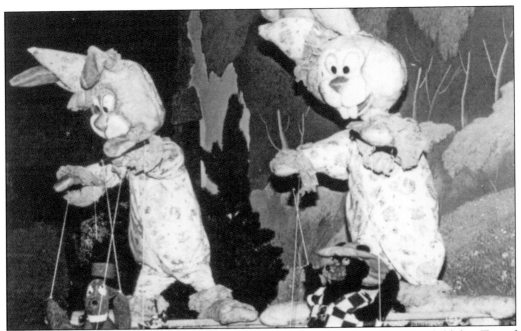

After passing through more colorful foliage, the entire rabbit family is having a field day. Two of the young rabbits have rigged up a marionette show, where the puppets are unflattering caricatures of Mr. Fox and Mr. Bear. (Bob Armstrong collection.)

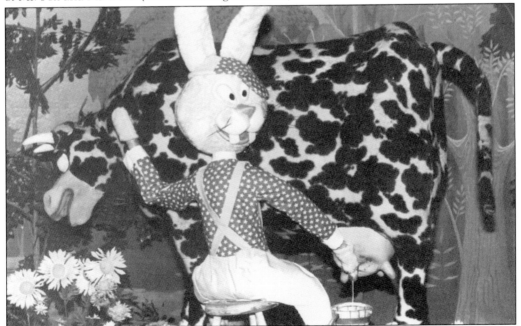

Near the puppet show, Mr. Rabbit has cornered a cow and is milking her for all she is worth, as the rest of his family helps out by carrying buckets. We soon encounter the hillbilly crows again, but this time they warn, "Before you go further, we just thought we'd warn ya/Those creatures up ahead there are liable to scorn ya." (Bob Armstrong collection.)

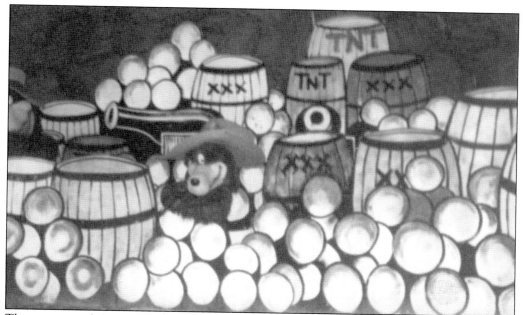

The water speed slows as we drift into a cave; glowing under black light is the secret arsenal of Mr. Fox and Mr. Bear. As if their supply of explosives is not bad enough, the two malefactors are blazing away at the boat with their rifles. (Author's collection.)

The boat starts to climb a steep incline, heading toward an enormous fallen tree. Above, Mr. Fox and Mr. Bear are swinging red lanterns and shouting, "Beware! Beware! Go back! Go back!" Unfortunately there isn't much to do to alter the course. (Author's collection.)

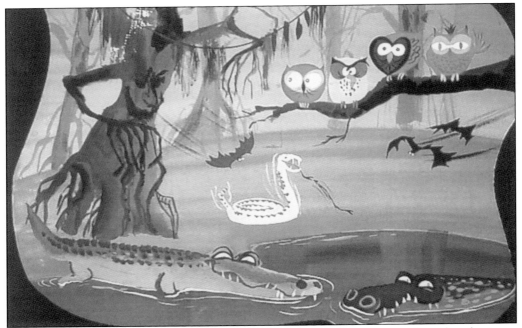

We plunge down the other side of the incline and are engulfed in a tremendous thunderstorm. Frightening sights appear everywhere: flying bats, trees with evil faces, alligators with snapping jaws, and owls with glowing eyes. Finally, in the distance, we spy the fearsome briar patch. (Dan Goodsell collection.)

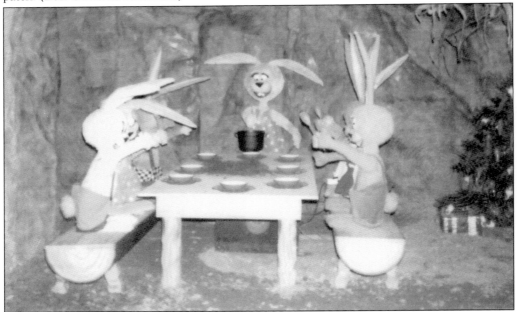

Everyone knows the briar patch is the home of Mr. Rabbit, and we find ourselves in the bunnies' burrow, where a never-ending Christmas celebration is taking place. Mr. Rabbit carves a giant carrot as if it were a roast turkey, while the little rabbits pound impatiently on the table, and Miz Rabbit slaves over the rest of the dinner. (Manuel Fernandez collection.)

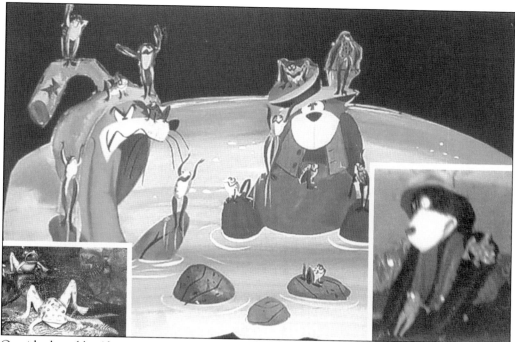

Outside the rabbits' home, the storm has passed, and Mr. Fox and Mr. Bear have ended up sitting soggily in the millpond. They are covered from head to toe in croaking frogs, and both seem somewhat nonplussed by it all. (Dan Goodsell collection.)

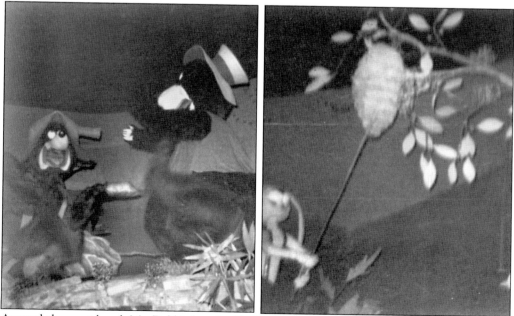

Around the next bend, Mr. Rabbit has finally fixed his two enemies for a good long while. He is using a pole to whack a large hornets' nest, and the angry swarm is chasing the fear-crazed criminals into the middle distance. (Author's collection.)

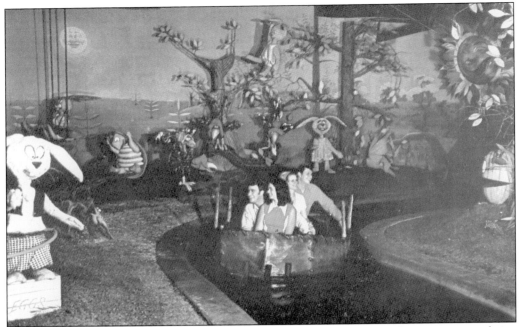

The final scene is one of celebration. The entire cast comes together to throw a party and sing the swamp's anthem: "The Okefenokee is an old hokey pokey/She don't never hurry 'cause she ain't got no worries/Just moseys along with a smile and a song/Take her advice and you'll never go wrong!" (Author's collection.)

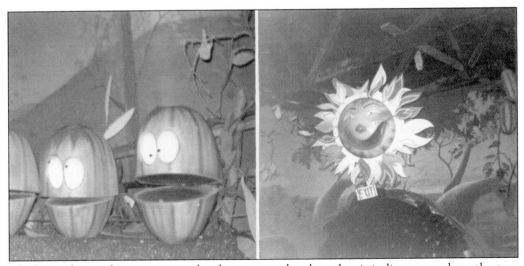

The last sights in the swamp are a laughing sun and a plant that is indigenous only to the true Southland: a watermelon tree. Some of the melons have even sprouted eyes and mouths. From the shore, Miz Rabbit waves and coos, "Bye now—ya'll hurry back, y'hear?" (Author's collection.)

Five

THE SPANISH SECTION

For many years, the Spanish section could barely be called a "section" at all, since the majority of the contents were crowded into one building. That was Castillo DeSoto, another of Six Flags' architectural components that was not technically based upon Georgia history. Instead the cream-and-pink fort was a replica of a well-known (but less colorful) bastion in St. Augustine, Florida, the Castillo de San Marcos.

Castillo DeSoto contained a poster shop, a candle shop, and the Casa de Fritos restaurant, but its largest element had nothing to do with the Spanish theme at all. The 1967 Six Flags map shows one whole section of the fort devoted to the "Casa Loco," with a cartoon drawing of a guffawing man. If this is really an accurate reflection of the first operating season, some drastic changes were made immediately thereafter, because that same space was soon occupied by the Horror Cave, about which there was certainly nothing to laugh at.

The Horror Cave was another witches' brew concocted by the wizards at Sid and Marty Krofft's headquarters, and it went in about as opposite a direction as can be imagined from their television output and the lovable characters of the Okefenokee. Decapitated corpses, giant blood-sucking spiders, Creature from the Black Lagoon clones, and other spooky citizens gave the kids of Atlanta nightmares until the whole thing was given a stake through the heart in 1985.

A few attractions managed to cling to the area immediately outside the fort. The most famous of these was the Casa Magnetica—the relocated Casa Loco, which had been displaced by the horrors of the Horror Cave. It was a classic "tilt house," a permanent fixture of every tourist area worth its tacos. On the other side of the fort was a game in which young conquistadors could practice firing wax cannonballs at targets in a small lake.

In the 1970s, Six Flags installed some kiddie rides with a Spanish (or, more correctly, Mexican) theme in this section. Some of these were retained and rethemed after the takeover by the Looney Tunes cartoon bunch in 1985, but others were not. Today's Bugs Bunny World exists as a sort of suburb in the larger Spanish metropolis, with gags aplenty based on the classic Warner Brothers cartoons.

Six Flags' Castillo DeSoto, the primary feature of the Spanish section, was modeled after the Castillo de San Marcos in St. Augustine, Florida. (Author's collection.)

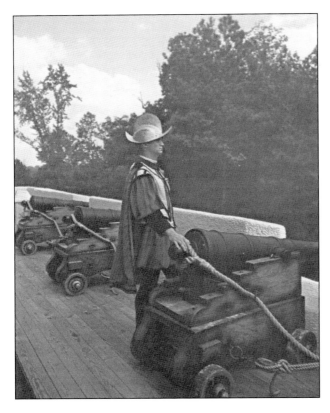

Although not considered costumed characters in the same vein as Pufnstuf and the others, Spanish conquistadors hung their helmets around Castillo DeSoto to give the fortress the appropriate flavor. (Author's collection.)

Most of the Spanish section's attractions were located within the Castillo DeSoto's walls, but guests could also ascend to the top of the fort for some target practice. These cannons (above) would be used to shoot wax cannonballs at a target (below). The former location of the target is now home to Splashwater Falls, and park employees report that the hill behind the water coaster is still littered with half-buried wax cannonballs. (Six Flags collection.)

The Casa Magnetica was known as Casa Loco during the 1967 season and was located inside the Spanish fort. In 1968, its space became the location for the new Horror Cave, and Casa Magnetica moved into a building of its own. Its slanting floor made the law of gravity seem to be repealed. (Six Flags collection.)

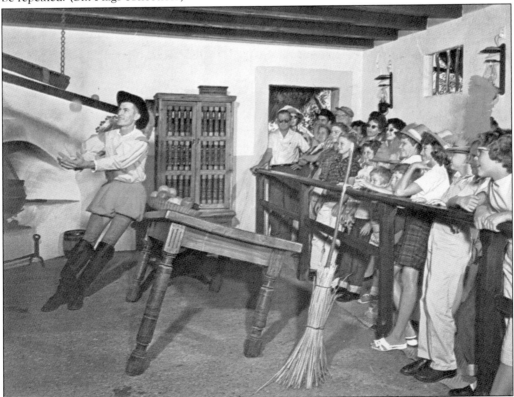

This Spanish-flavor drinking fountain and pair of telephone booths give a great example of how pervasive Six Flags made the themes of each of its sections in the early days. (Six Flags collection.)

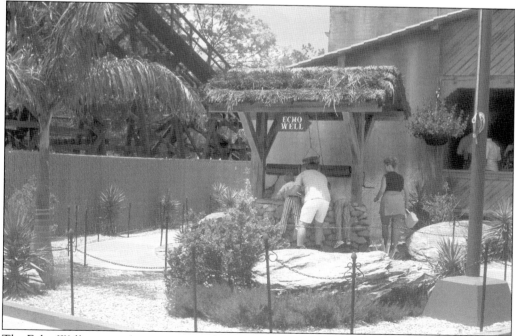

The Echo Well was an almost-unnoticed park feature squeezed between the Casa Magnetica and the Yahoola Hooler Mini-Mine Train. It contained a tape recorder that would instantly replay any voice shouted into the well, hence the name. (Six Flags collection.)

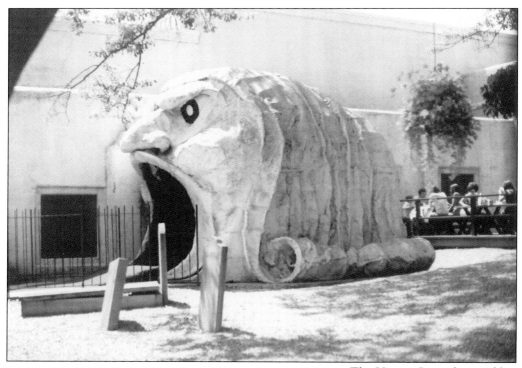

The Horror Cave, designed by Sid and Marty Krofft for the 1968 operating season, was entered through the gaping mouth of this creepy head. That was nothing compared to the creeps that waited inside. (Andy Duckett collection.)

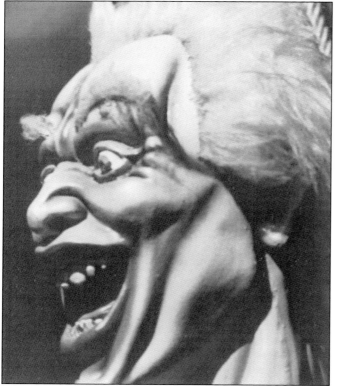

In one horribly memorable scene in the Horror Cave, this maniac brandished a skill saw and the head of a woman he had just severed from her body, which lay outstretched across the bed in her ornate room, blood pouring out of her neck. Pleasant dreams, everyone! (Author's collection.)

Out of a bubbling, churning pool of water arose the Creature from the Black Lagoon—or at least a close facsimile of Universal's copyrighted movie monster. (Manuel Fernandez collection.)

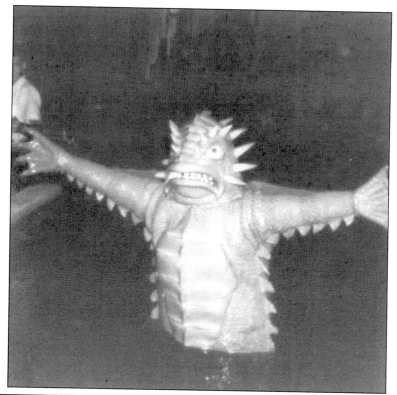

A visit to the Horror Cave included a peek into the mad scientist's laboratory, where a flip of the switch brought the fiend's monster to life. This photograph is a bit blurred, but if you were gazing upon this scene, you would probably be shivering, too. (Andy Duckett collection.)

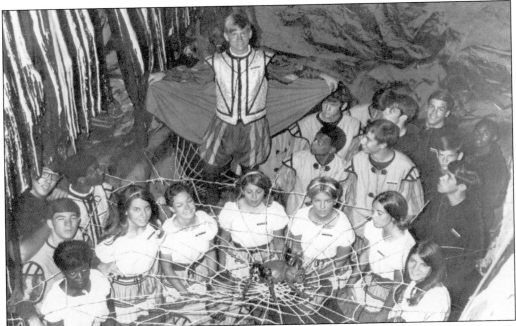

One high point (literally) of the Horror Cave was a trip across a "squishy bridge" over a pit containing this man-eating spider. A shriveled body, drained of its blood, was all that remained of the last unfortunate victim. (Six Flags collection.)

These husband-and-wife vampires sleep like the undead in the Horror Cave. You can be sure that visitors tiptoe past their coffins very quietly, lest the couple decide to get up and have a bite as a midnight snack. (Manuel Fernandez collection.)

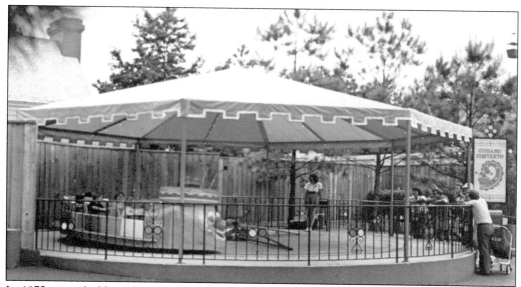

In 1975, some kiddie rides were added to the Spanish section. Although the mechanisms were fairly standard carnival equipment, the figures and theming were created by Six Flags' own in-house artist Fernando Plazaola. Two examples of these were the Happy Worm ride (above) and the Jumping Frijoles (below), both of which carried on the Hispanic theme. When this area was rethemed as Looney Tunes Land in 1985, many of the same rides remained but were given cartoon character overtones. (Andy Duckett collection.)

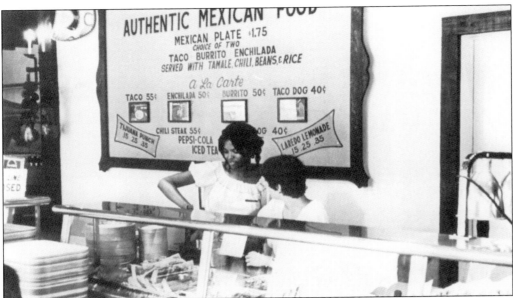

The Casa de Fritos restaurant inside the Spanish fort sounded as if it should have specialized in serving corn chips, but in this 1972 shot, "authentic Mexican food" was on the menu. The prices were quoted in dollars and cents rather than pesos, however. (Six Flags collection.)

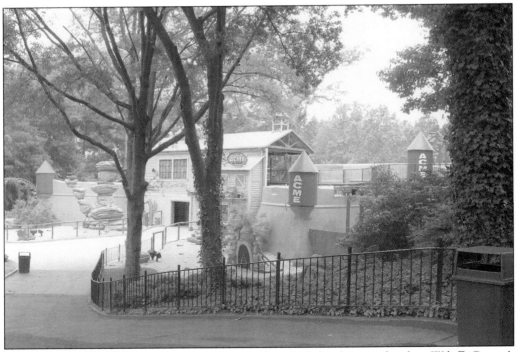

The former Castillo DeSoto is almost unrecognizable today behind its new facade as Wile E. Coyote's Canyon Blaster. The hapless predator's Acme gadgets cover what were once the fort's turrets. What would Hernando himself have thought of these developments? (Author's collection.)

Six

THE FRENCH SECTION

Six Flags' French section had the most foggily defined boundaries of any part of the park. The dividing line between it and the Spanish section was nonexistent; the division between French and Confederate was even more obscure, so much so that Six Flags maps of recent years have placed the Monster Plantation (formerly Tales of the Okefenokee, the centerpiece of the Confederate section) in the French section instead. Someone definitely fell down in the mapmaking department when pioneering this area.

And speaking of pioneering mapmakers, the primary attraction in the French section was a "Georgiafied" version of Six Flags Over Texas's "LaSalle's Adventures" riverboat ride. Here it dealt with a completely different part of history and was known as "Jean Ribaut's Adventure" (for some reason, the singular form was consistently used, rather than "Adventures"). We will be examining that classic attraction more fully in the next chapter.

The rest of the French section seemed positively dull compared to the adventures of Ribaut. Lafayette's Shooting Gallery made its noisy presence known in a stockade-like structure that also housed the French Trading Post souvenir store. The food service industry was represented by the Gaslight on the Green restaurant, which served appetizing fare but had no real connection to the French theme. For less genteel diners, there was an outdoor picnic area known as Watermelon Waterloo, where guests could slurp down that Southern snack treat and spit out the seeds wherever they pleased.

The remaining attraction is difficult to place in the French section, because it also lay partially in the Spanish section and didn't have anything to do thematically with either section. This was the famous performing porpoise show, starring those two megastar mammals Skipper and Dolly. After the porpoises (or bottle-nosed dolphins, their interchangeable name) made their final high jump, the pool and arena were used for a variety of other shows, but none of those performers made the lasting impression of Six Flags' two Flipper wannabes.

Directly opposite each other were the Lost Parents building and the Rabun Gap depot of the Six Flags Railroad. Rabun Gap was the counterpart to the Marthasville depot in the Confederate section. Immediately to the left of the depot was a gate that heralded the French section giving way to the modern U.S.A. section, relegating Jean Ribaut and all of his French friends and enemies to history.

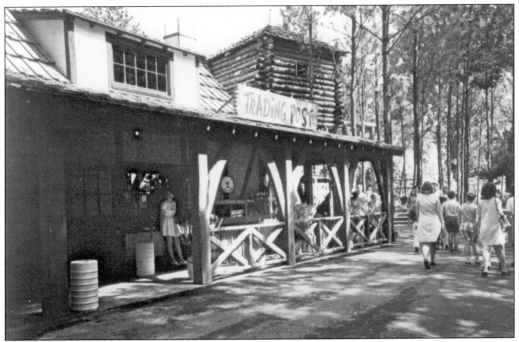

This trading post was the primary outlet for souvenirs and gifts in the French section. Probably few people noticed that it was a very close replica of the trading post seen along the banks of the Jean Ribaut's Adventure riverboat ride. (Author's collection.)

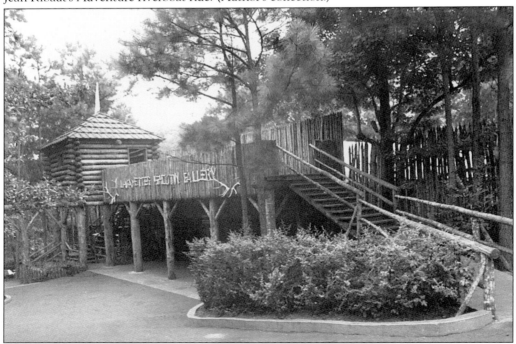

Lafayette's Shooting Gallery was the place for amateur sharpshooters to practice their craft. Along with Gen. John Pershing, they could declare, "Lafayette, we are here." (Six Flags collection.)

The Rabun Gap depot of the Six Flags Railroad was a half circuit around the park from the Marthasville depot in the Confederate section. It was named for a gap in northern Georgia that early settlers used to pass through the mountains into the state. (Author's collection.)

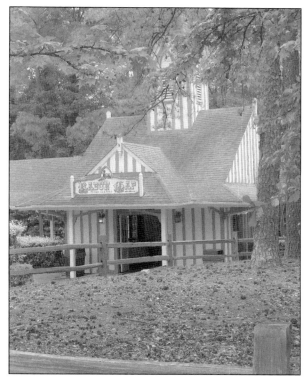

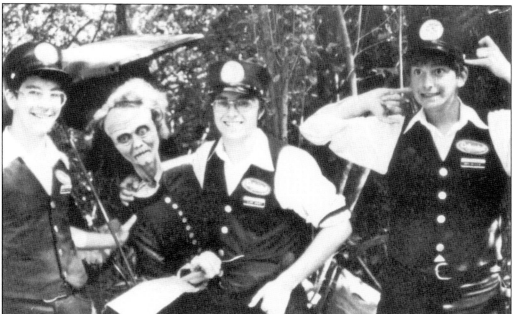

One of the sights as the railroad pulled out of Rabun Gap was the eerie home of Grandma Flagerty, complete with clutching hands protruding from the well. Here, from left to right, railroad conductors Raymond Cloutier, Claude Specht, and Jeff Ogilvie clown around with the gruesome granny herself. (Bob Armstrong collection.)

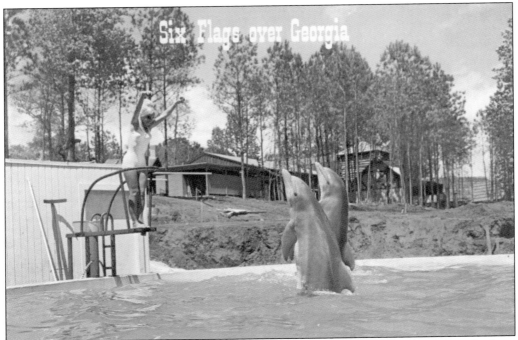

The porpoise pool was located on the border between the Spanish and French sections. In these shots from the first couple of years, porpoise trainer Kathy Bennett puts her stars, Skipper and Dolly, through their paces. Bennett and the two bottle-nosed dolphins became so emotionally attached to each other that she felt she had abandoned two of her children when her work required her to leave Six Flags for an amusement park in New Jersey. (Author's collection.)

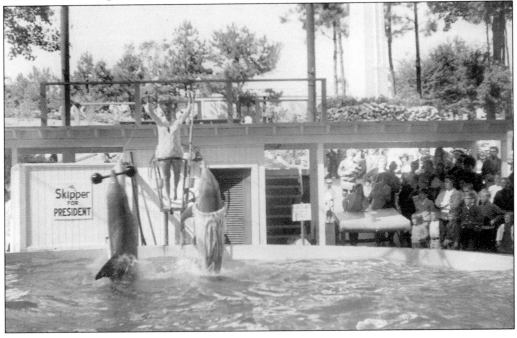

By 1978, the porpoise/dolphin show had undergone a number of trainers since Kathy Bennett's tenure and was sponsored by Quaker Oats and Cap'n Crunch cereal. (Bob Armstrong collection.)

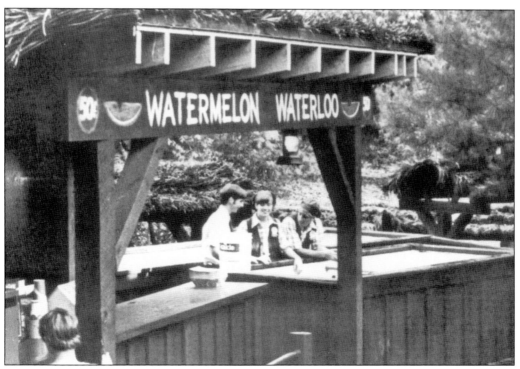

Watermelon Waterloo was the outdoor picnic area where tourists could cool off. On sweltering summer days, the employees fought the temptation to dive headfirst into the refrigerated watermelon coolers themselves. (Six Flags collection.)

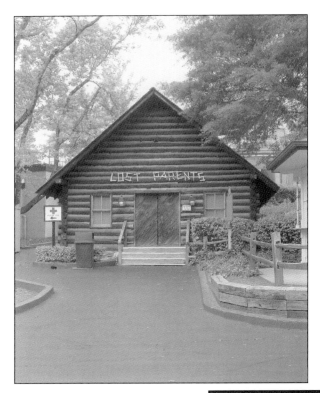

Lost Parents, for families separated by fun, was housed in a replica of the first schoolhouse in Fulton County, built in 1857 on the outskirts of Atlanta by future Confederate lieutenant Clem Greene. Even the replica bears a state historical marker, having been constructed in 1957 on the site of the original before being moved to Six Flags 10 years later. (Author's collection.)

Those needing some sustenance before leaving France for the U.S.A. section could stop in at the Gaslight on the Green restaurant. This moody nighttime shot captures the closed eatery with the gigantic Sky Hook ride looming in the distance. (Six Flags collection.)

Seven

JEAN RIBAUT'S ADVENTURE

While names such as DeSoto and LaSalle are familiar to any elementary-school-age history buff, many people may have wondered out loud who Jean Ribaut was and why Six Flags named an entire outdoor ride after him. An early explanation from the park went into detail: "In the mid-1500s, French explorer Jean Ribaut cruised the Georgia coast, reporting the discovery of a 'Country full of harbors, rivers and islands of such fruitfulness as cannot with the tongue be expressed.' Even today, the daring riverboat captains relive the captivating tale of mystery, excitement, and beauty that awaited the early French explorers. The English colonists, in an effort to protect themselves from the adventuresome French, constructed the legendary well-fortified Fort Argyle in 1733 on the banks of the Ogeechee River. Each adventure down the river at Six Flags culminates in a wild and explosive encounter with the English cannons at Fort Argyle."

That sums up what the Jean Ribaut's Adventure ride was all about. Along the banks of the man-made river were animated figures acting out some of the key events in early Georgia history, compressing approximately 200 years into a few minutes. The riverboat captains' spiel is said to have been modeled after that of the Disneyland Jungle Cruise and reportedly varied according to how wacky a sense of humor the particular captain possessed. Some chose to present a history lesson, while others made every trip into a stand-up comedy act.

After the 1981 season, Jean Ribaut's Adventure came to an end that not even the blazing cannons of Fort Argyle could cause. With a new craze for whitewater rafting rides sweeping theme parks, the Ribaut trough was dredged, widened, and converted into today's Thunder River. Some isolated examples of the original Ribaut landscaping can still be found along the banks of Thunder River, invisible and unnoticed by whitewater enthusiasts who are too busy rushing past and getting wet to even think about a French explorer of 500 years ago.

As with the Okefenokee ride a couple of chapters ago, we are here going to attempt to recreate Ribaut's adventures by using available photographs. Unfortunately not every scene along the riverbanks was preserved in a form suitable for reproduction, but we are going to give it our best shot, even as the defenders of Fort Argyle take shots at us once more.

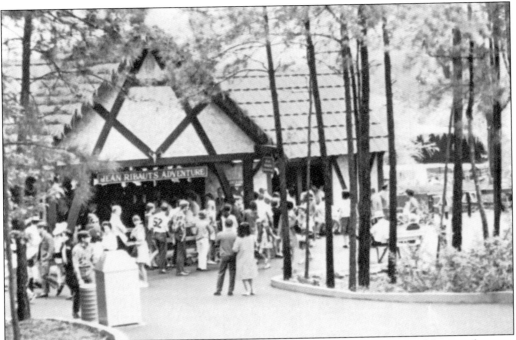

Those who decided to try braving the Georgia wilderness with Jean Ribaut could await the next riverboat in this rustic entrance building, which still exists as the Thunder River observation deck. (Author's collection.)

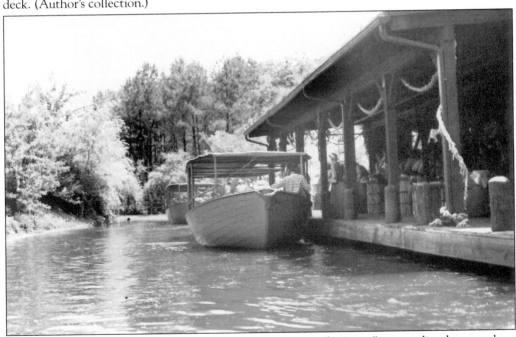

Although the Ribaut riverboats appeared to float freely down the "river," in actuality they ran along a rail that was buried in the river bed. Unlike rides such as the Log Flume and the Okefenokee, the water itself did not have to propel the boats along. (Andy Duckett collection.)

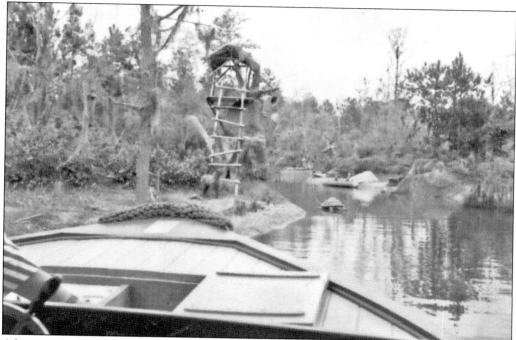

After an encounter with a family of bears, the captain points out one of the first signs of civilization ahead: two Native American boys playfully swinging from the branches surrounding their tree house. (Manuel Fernandez collection.)

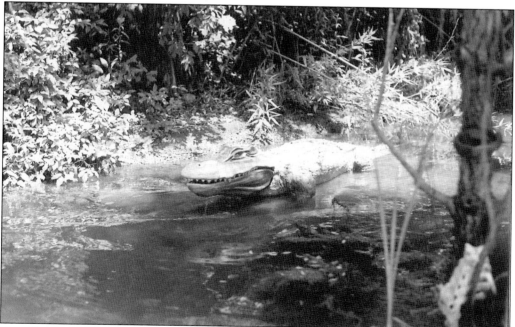

Not all is fun and games on this perilous journey down the Ogeechee, however; near the Native American boys' tree house, the boat is attacked on the right hand side by this charging alligator, complete with snapping jaws. (Andy Duckett collection.)

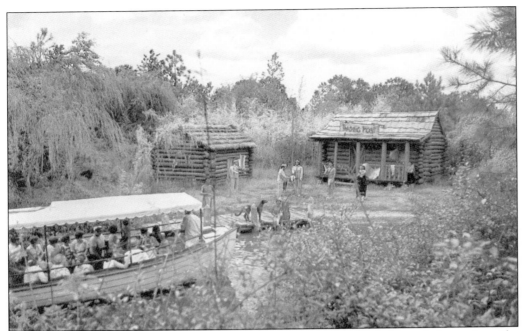

Ah, other humans at last! This trading post scene was the showpiece of the entire ride. Here in its first year, it looks a bit empty, but more animated figures were added each year, eventually including a woman churning butter and several Native Americans having a powwow. (Karen Clark collection.)

After passing a treacherous whirlpool, with a human arm protruding from the water as the victim goes down for the third time, the boat is almost hit by a falling tree gnawed by these beavers. Occasionally smart-alecky skippers would instruct their passengers to look behind them to see the tree spring back up into position after the boat passed. (Author's collection.)

We have now skipped almost 200 years ahead in time to 1733. Gen. James Oglethorpe and his men are paying a call on Tomachichi, chief of the Yamacraws, to ensure peace between the tribe and the British settlers around Savannah. (Wayne Neuwirth collection.)

While the peace conference is going on to the left, on the right is an example of why said treaty was necessary. Two of Tomachichi's braves are about to throw a big backyard barbecue for the British, with a surprise guest star. (Author's collection.)

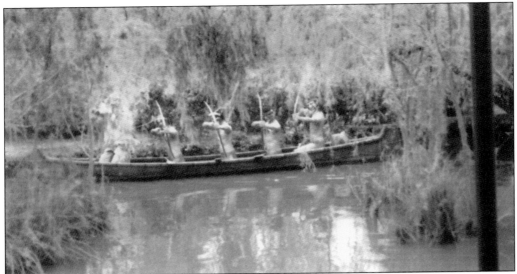

It looks like we could be in for more trouble, as this canoe stealthily glides its way through the willows and bamboo. Fortunately none of the arrows cause any casualties among our passengers. (Manuel Fernandez collection.)

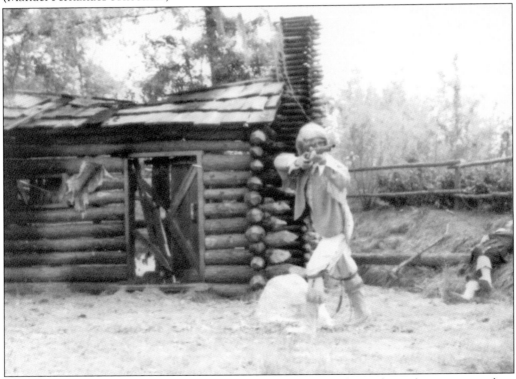

Now things begin to get a bit heated. We pass a burning cabin, where the occupant does not seem to be happy with our boatload of French rubberneckers. Ironically the cabin scene eventually had to be removed because the gas-powered flames actually did burn it down. (Manuel Fernandez collection.)

Although we proceed quietly and cautiously, our captain soon descends into panic mode as we are fired upon by the cannons of Fort Argyle. Compressed air beneath the water's surface was timed with the cannon blasts to give a convincing effect (and more than one passenger received a face full of water in the process). (Author's collection.)

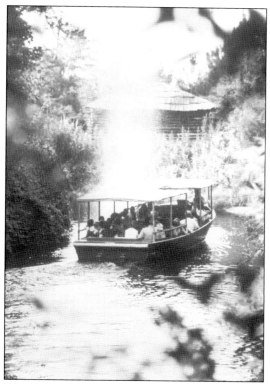

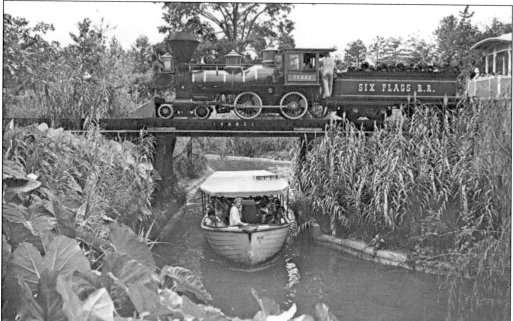

Escaping the cannon fire, the skipper triumphantly shouts "Viva la France!" as he brings yet another boatload of passengers under the tracks of the railroad and safely back to the loading dock. It's been an amazing journey! (Author's collection.)

Six Flags maintenance foreman Carl Marquardt looks appropriately pensive as he observes the transformation of Jean Ribaut's Adventure into Thunder River over the winter of 1981–1982. (Carl Marquardt collection.)

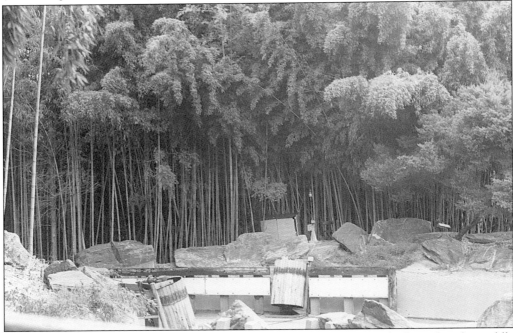

The bamboo that was planted as part of the Ribaut scenery has apparently thrived in the middle Georgia soil, because it is still growing along the banks of Thunder River today. This is next to the former location of the trading post scene. (Author's collection.)

Eight

THE U.S.A. SECTION

The U.S.A. section was alternately known as the "modern" section, and as such had a problem: how can an artificial theme park environment ever hope to move at the same pace as real life, so that what is considered "modern" today will not look stodgy and quaint five years from now? Six Flags finally learned how to deal with this sticking point, but first of all let's take a look at how the U.S.A. section looked when it really was considered to be "modern."

The first U.S.A. attraction along the walkway was the Happy Motoring Freeway, sponsored by the Texas-based Humble Oil Company. After the 1975 season, the Happy Motoring Freeway was given the stop sign, and the entire track was plowed up to make room for the parachute-drop ride known as the Great Gasp, which ultimately had its last gasp in 2005 before being cleared away for the giant Goliath roller coaster. Directly across from the freeway was the Petsville petting zoo, and adjoining that was the Animal Fair store, where kids could take home stuffed animals instead of the living, breathing, and eating variety.

With its theme so loosely defined, the U.S.A. section became the most logical place to put traditional amusement park rides. The two spinning Satellite Rides were good examples of these, while thousands of visitors boarded the Sky Hook's two suspended cages for a trip aloft, one cage being raised while the other was lowered, in the fashion of two buckets in a well.

Flanking the Sky Hook on either side were two theaters, each with its own approach to entertainment: the fabulous Krofft Puppet Theater and the Chevy Show, a domed building in which a movie was projected in a 180-degree half-circle around the audience. Outside the theater was a glass dome under which a late-model Chevrolet rotated on a turntable, periodically flying apart to expose its interior structure and then coming back together again.

There was something futile about trying to keep up with the fickle public's idea of what "modern" entailed. In the 1990s, Six Flags tackled this challenge by taking the U.S.A. backward in time to the 1950s. No longer "modern," the area became the home to nostalgic drive-in theaters and restaurants, and since the 1950s have already been here and gone, no one had to worry about it looking outmoded anymore.

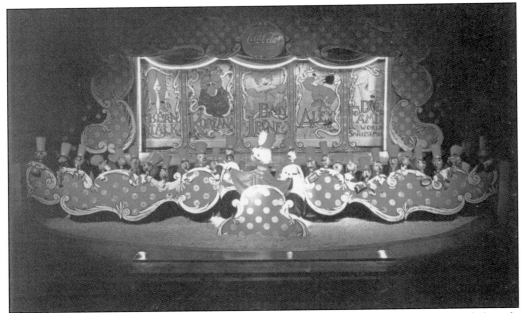

The original 1967 Krofft puppet production for Six Flags, *Circus*, was a series of extremely loosely connected skits featuring the voices of such celebrities as Lucille Ball, Jackie Gleason, Liberace, and Mae West. (Author's collection.)

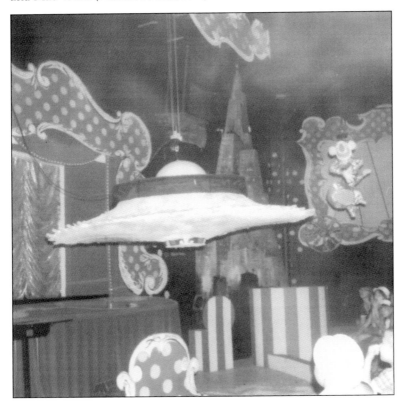

At one point during the *Circus* production, a flying saucer descended from the ceiling to land on the stage. On the wall, notice the circus wagons that were actually shadow boxes revealing animated animals when lit from the back. (Manuel Fernandez collection.)

This animated facade was added to the Krofft Puppet Theater for the 1968 season. For 1967, the building had been disguised as a circus tent, but the 1968 production, called *Funny World*, prompted this pastiche of international landmarks. (Thom Fountain collection.)

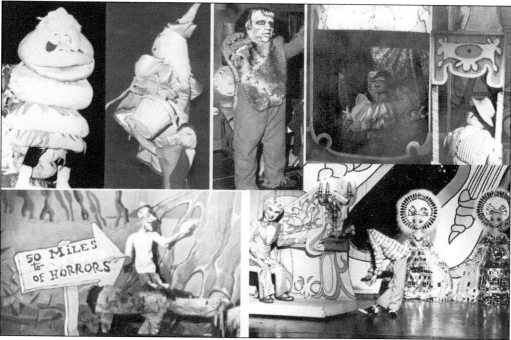

The Krofft theater featured a different show each season, but all contained an amazing assortment of kooky characters. Of particular interest are the witch and the armless dragon (named Luther) in the top left-hand corner; they would evolve into the stars of the Kroffts' first Saturday-morning series, *H. R. Pufnstuf*, in September 1969. (Six Flags collection.)

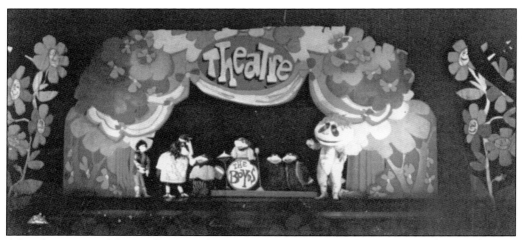

After the success of the Kroffts' Saturday-morning programming, their 1970 Six Flags production was quite naturally based on the *H. R. Pufnstuf* television series. It combined costumed actors with marionettes and hand puppets, all illuminated under black light. (Author's collection.)

Because the theme of the U.S.A. section was so loosely defined, it became a natural home for amusement-style rides that did not seem to fit in anywhere else. The two spinning Satellite Rides were good examples of these. (Six Flags collection.)

Following the Kroffts' somewhat abrupt departure after the 1974 season to open their own theme park, Six Flags was left with a giant empty theater. The park's 1975 attempt to do something about it was the American Pie show, which from this description sounds as if it pretty much carried on the same concept and style of what had gone before, perhaps in the hope that no one would notice the Kroffts were gone. (Six Flags collection.)

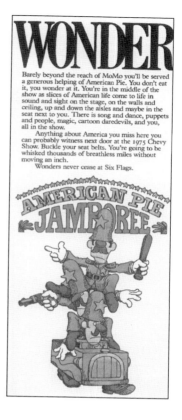

WONDER

Barely beyond the reach of MoMo you'll be served a generous helping of American Pie. You don't eat it, you wonder at it. You're in the middle of the show as slices of American life come to life in sound and sight on the stage, on the walls and ceiling, up and down the aisles and maybe in the seat next to you. There is song and dance, puppets and people, magic, cartoon daredevils, and you, all in the show.

Anything about America you miss here you can probably witness next door at the 1975 Chevy Show. Buckle your seat belts. You're going to be whisked thousands of breathless miles without moving an inch.

Wonders never cease at Six Flags.

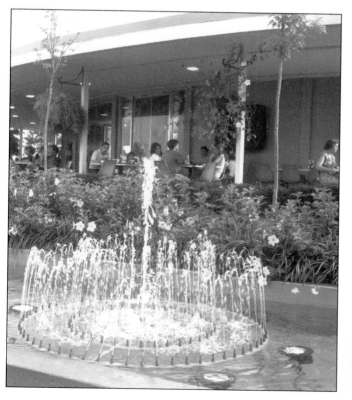

There have been plenty of jokes over the years about Atlanta's propensity for naming its streets and roads Peachtree, leading to many lost and disoriented visitors. Six Flags got into the act with the easier-to-find Peachtree Cafeteria in the U.S.A. section, identifiable by its dancing fountains in front. (Six Flags collection.)

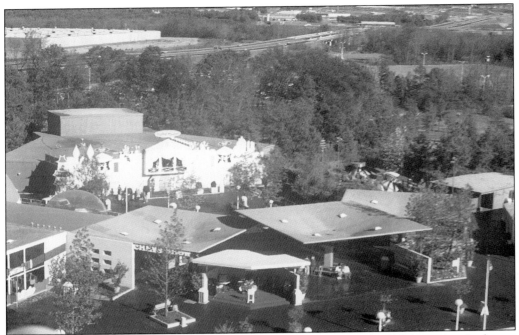

These two great shots demonstrate the gradual changes taking place in the U.S.A. section. In the top photograph are the Krofft theater, the Satellite Rides, and the "paraboloids" (shady shelters so named because together they illustrated that mathematical term). Below, after the Kroffts' departure, the facade has been removed and the building renamed the Bicentennial Theater, while the Satellites have spun away to be replaced by MoMo the Monster. (Shaunnon Drake collection.)

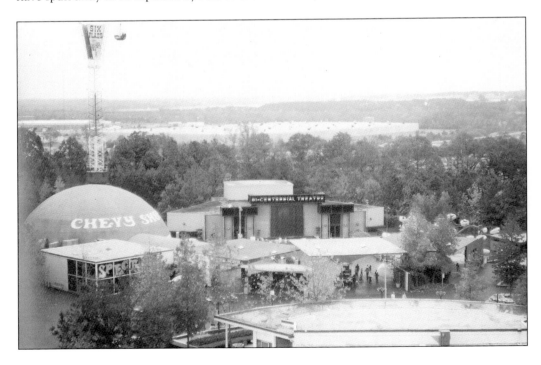

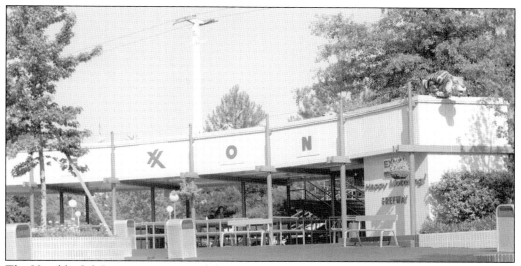

The Humble Oil Company sponsored the Happy Motoring Freeway; over the years, its gasoline brand name would change from Enco to Exxon. At far right, notice the three-dimensional rendition of the corporation's tiger trademark character crouching over one end of the facade. (Nelson Boyd collection.)

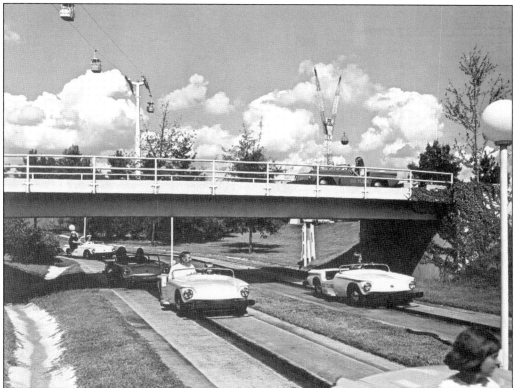

Covering more ground than any other attraction in the U.S.A. section, the Happy Motoring Freeway gave white-knuckled parents a chance to experience what it would be like when their kids started learning to drive. (Author's collection.)

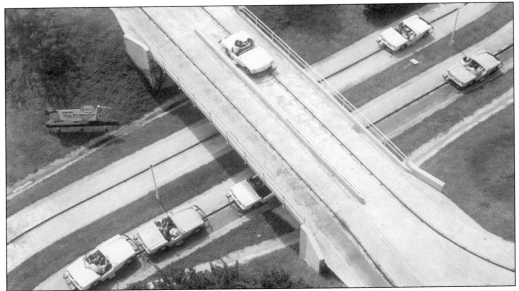

Humble Oil used miniature billboards along the Happy Motoring Freeway to promote its brand of gasoline and also to make the landscape more closely resemble the real interstate highways that crisscrossed the nation. (Six Flags collection.)

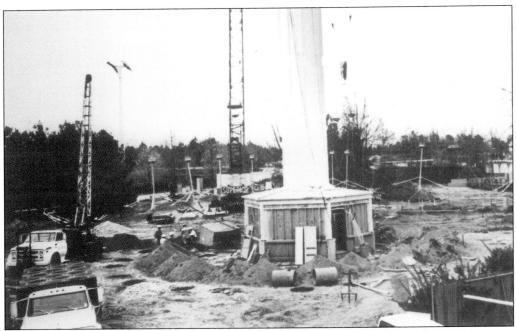

Over the winter of 1975–1976, the Happy Motoring Freeway was plowed up and tons of concrete were poured into the earth to form the foundation for the new Great Gasp parachute-drop ride. (Six Flags collection.)

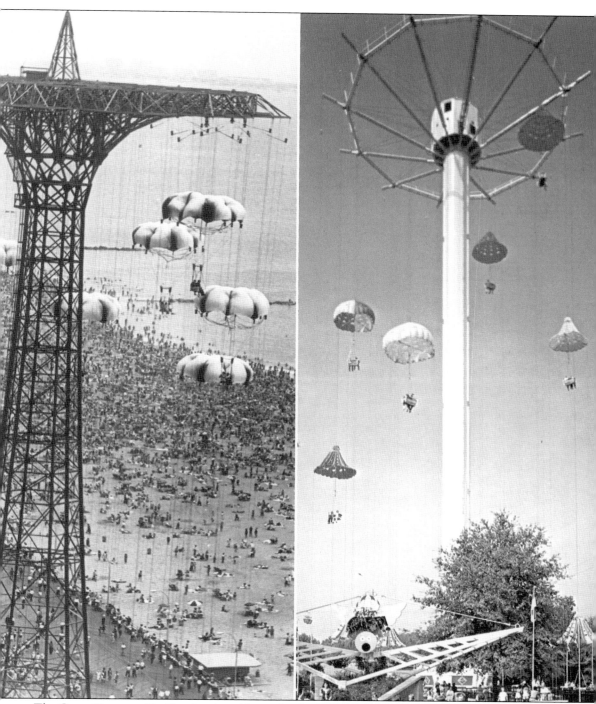

The Great Gasp was Six Flags' major addition for the 1976 season. It was based on the parachute-drop ride that had debuted at the 1939 New York World's Fair and later played out its days at Coney Island. Six Flags' publicity photographs placed their sleek Great Gasp in juxtaposition with the older, cruder New York version. (Six Flags collection.)

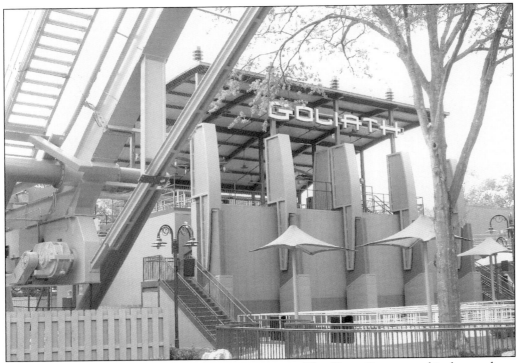

The Great Gasp gasped its last at the end of the 2005 season, after which its spot became the launching pad for Goliath, easily the largest and longest coaster ever built at Six Flags. The deep concrete foundation of the Gasp still rests underneath Goliath in a silent tomb. (Author's collection.)

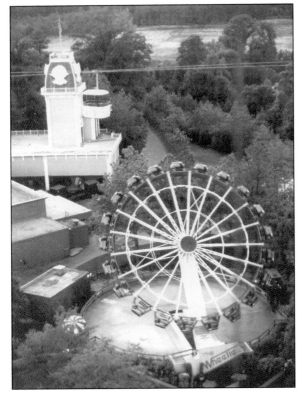

The popular Wheelie ride was situated behind the Great Gasp, on the border of the Confederate section. The U.S.A.-Confederate Sky Lift buckets passed directly over it. (Andy Duckett collection.)

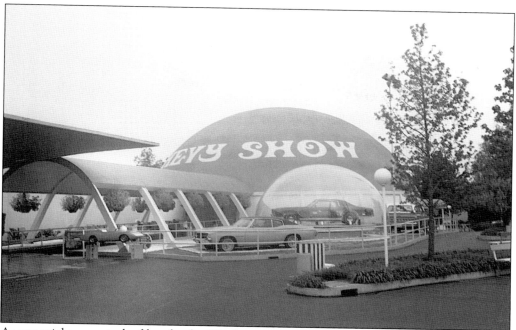

As one might expect, the films for the 180-degree Chevy Show were supplied by Chevrolet, and they sought to give the impression of riding a roller coaster, zooming down a highway, and other such high-speed activities. Reports are that some viewers would actually develop motion sickness because of the films' realism. (Six Flags collection.)

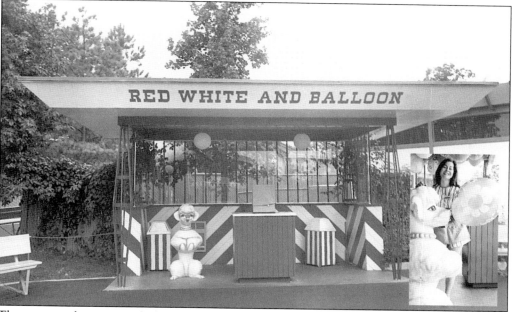

There was nothing particularly unique about a stand selling helium balloons, but the one in the U.S.A. section (Red, White, and Balloon) attracted attention by concealing the helium tank inside a mock French poodle, making it appear that the pooch was supplying the lung power. (Six Flags collection.)

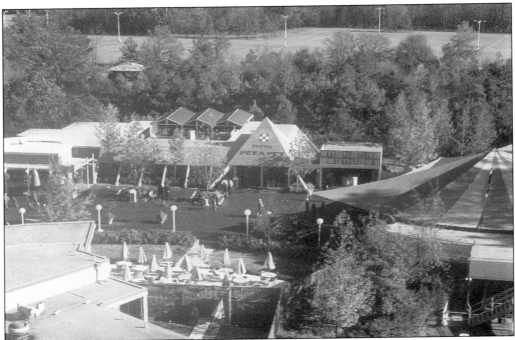

Ralston-Purina sponsored Six Flags' petting zoo, but the name of the attraction seemed to be in a constant state of flux. It was consistently referred to as Petsville on park maps and other promotional items, yet the photograph above calls it "Pet-A-Pet." Under any name, it gave kids a chance to get up close and personal with domestic animals such as pigs, goats, rabbits, and more exotic critters, including deer and elephants. (Six Flags collection.)

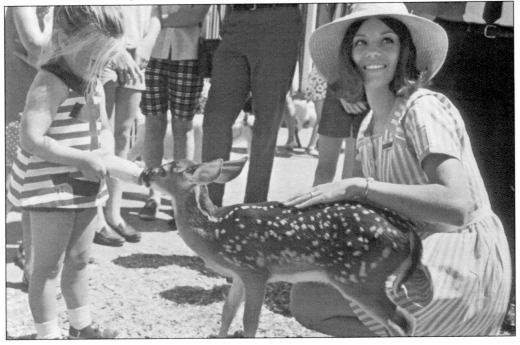

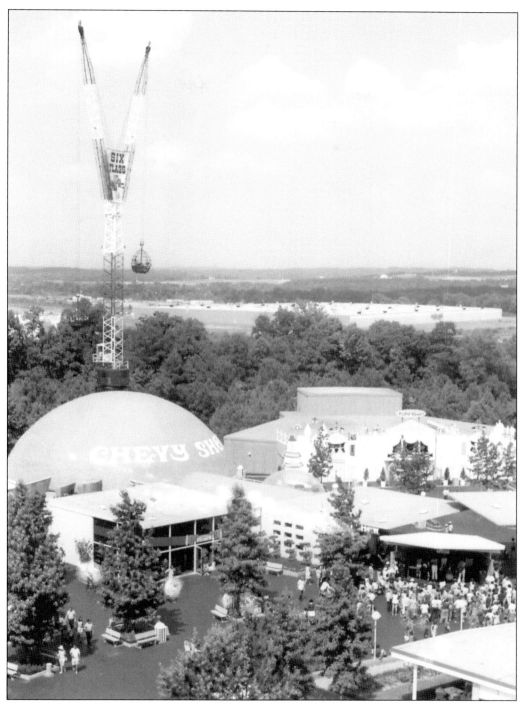

The Sky Hook had a life of its own both before and after its career at Six Flags. It was originally created for the 1958 Brussels World's Fair, then in 1963, it towered above Six Flags Over Texas. In 1969, it was moved to Georgia, where it became an I-20 landmark for the next eight years. (Andy Duckett collection.)

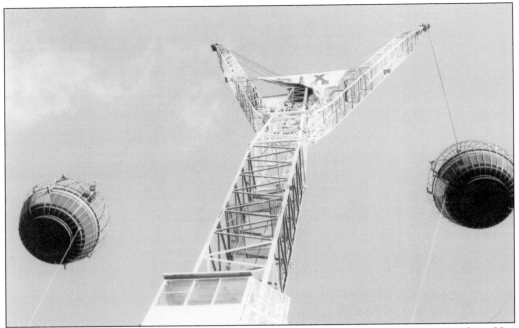

The Sky Hook got the hook in 1977 and ended up at the Magic Springs theme park in Hot Springs, Arkansas. Its last days in Atlanta were not a pretty sight, with its distinctive Six Flags banner hanging in tatters. (Andy Duckett collection.)

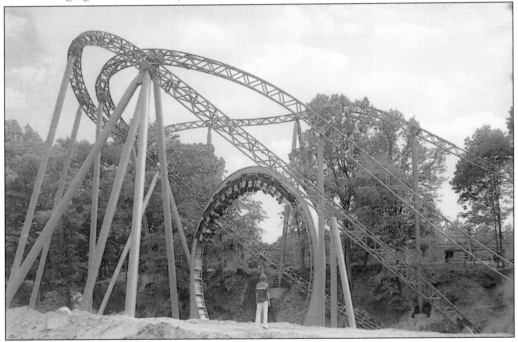

When the Mindbender was added to the U.S.A. section in 1978, it was the forerunner of Six Flags' almost total commitment to high-speed roller coasters, a business model that would last for most of the next three decades. (Author's collection.)

Nine

BEYOND THE SIX FLAGS

The original six themed areas of Six Flags had at least one thing in common: they were all located within the oval formed by the Six Flags Railroad track. That began to change in 1968. The attendance numbers of the first season had been encouraging enough to cause thoughts of expansion, and the only way to do that was to begin adding new sections to the park on the outside rim of the railroad track. That the additions had no relationship to the six nominal flags gave them a slightly different flavor, as least so far as historians were concerned. The general public, for its part, seems to take them all equally in stride—and it takes a lot of striding to get to all the remote corners of the park these days.

The first "outside" area to be added was Lickskillet, meant to represent a typical Georgia coal-mining town of the late 1800s. In 1972, Six Flags managed to get its hands on the magnificent carousel that had operated at Chicago's Riverview Park since 1908. Riverview had gone the way of many of its old-time amusement park cousins, and the carousel had sat dismantled in a warehouse since 1967. Six Flags brought it in piece by piece, reverently restored it, and reassembled it on a hilltop just north of the Spanish section.

Across the tracks from the carousel, Six Flags carried the "turn-of-the-century amusement park" theme to its logical next step with the opening of the Cotton States Exposition in 1973. This was the location for the standard arcade games and rides found in any classic midway. The focal point was the Great American Scream Machine, a wooden roller coaster credited with reviving the public's interest in that type of thrill ride.

In 1980, a new area, Jolly Roger's Island, was added just on the other side of the railroad track from the U.S.A. section. Buccaneers and treasure abounded, but apparently the public seemed to think Jolly Roger was a bit less than jolly, because within a few years the area began to lose some of its nautical definition. The individual who finally made the pirates walk the plank was none other than Batman himself. After the success of his movie franchise in 1989, the area was transformed into Gotham City, which is how it remains today.

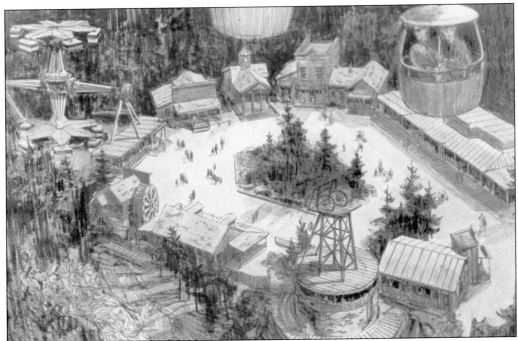

The Lickskillet area of Six Flags was named after, if not precisely modeled after, an actual Georgia coal-mining community later known as Adamsville. This early concept art shows how the section was intended to appear. (Six Flags collection.)

While strolling along the Lickskillet street, this might be a good time to mention the distinctive "Six Flags smell." It comes from a product called Jennite, a brand of asphalt sealer that contains rubber. When people encounter Jennite in shopping-center parking lots, it can trigger the same nostalgic memories as the scents of Play-Doh or Crayola crayons. (Author's collection.)

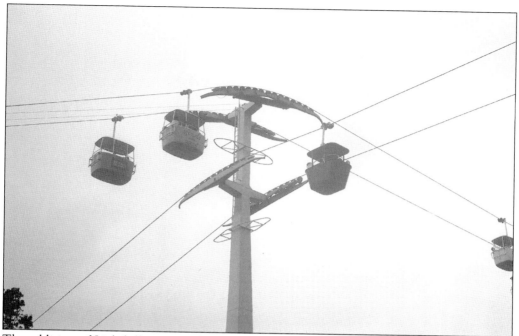

The addition of Lickskillet required a second sky lift to run between the new area and the Confederate section. This one was dubbed the Sky Buckets, and true to their name, they were made to look like dangling wooden pails. The two rides crossed each other at this junction. (Shaunnon Drake collection.)

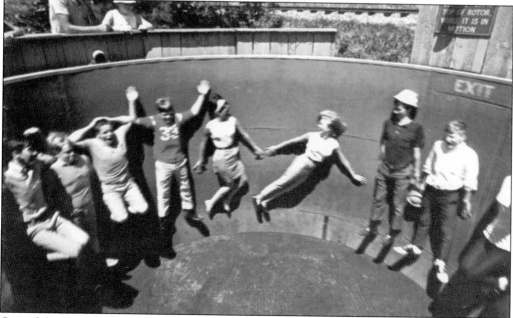

One of the most unusual rides in the whole park was the Spindle Top, which whirled at terrific speed until the floor dropped out from underneath the riders, leaving them plastered to the sides by centrifugal force. (Author's collection.)

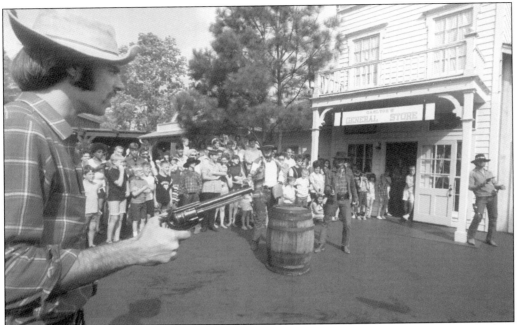

Because of elements such as these shoot-outs in the street, many people mistook Lickskillet for a Wild West town of the type that was so popular among roadside attractions of the day, such as Six Gun Territory and Ghost Town in the Sky. (Six Flags collection.)

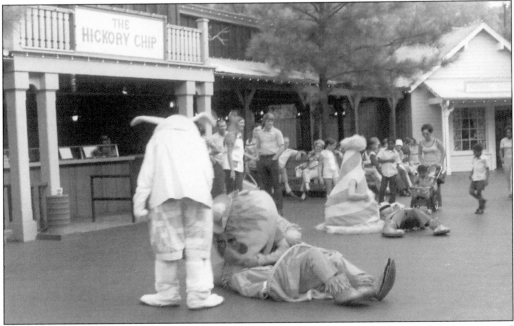

We aren't sure just what is going on in Lickskillet here, but it appears that Mr. Rabbit has gunned down Cling and Clang during a shootout, and Pufnstuf and Mrs. Ring-A-Ding the party hat are giving them mouth-to-mouth resuscitation. Are we still at Six Flags, or have we entered the Twilight Zone? (Andy Duckett collection.)

The Wheel Burrow was a sort of overgrown double Ferris wheel that started out by running horizontally and then gradually tilted upward into this vertigo-producing position. (Author's collection.)

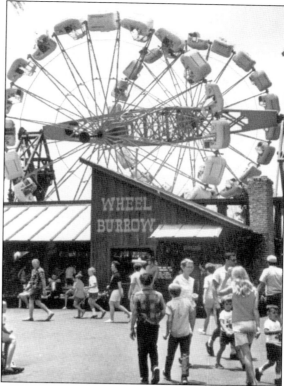

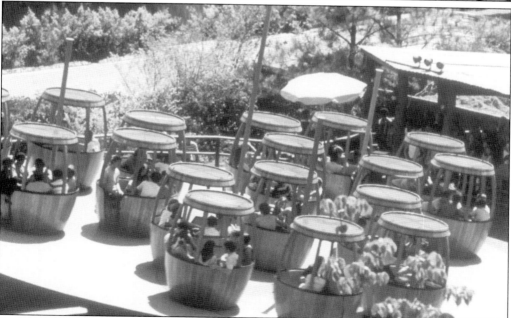

By the early 1970s, the Drunken Barrels had taken the place of the Wheel Burrow. They remained earthbound but were still intended to make riders walk as if they had just imbibed a jug of moonshine. (Nelson Boyd collection.)

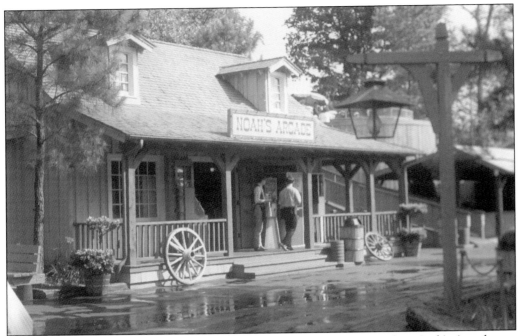

Lickskillet's emphasis was on shops and restaurants more than thrill rides. Noah's Arcade was a good example in the days before the word "arcade" became connected with video gambling. (Six Flags collection.)

Although the vast majority of visitors entered Six Flags through the front mall with its white columns, there was a rustic back gate in the Lickskillet neighborhood, near a picnic area. It was closed off and eliminated in 1998. (Bob Armstrong collection.)

Six Flags' prized carousel had a most distinguished history. Built in 1908 for Chicago's famed Riverview amusement park, the carousel and its hand-carved horses entertained visitors for six decades. When Riverview Park closed in 1967, the carousel was dismantled and sat in a warehouse until it was purchased by Six Flags, moved to Atlanta, painstakingly restored to its original glory, and reconstructed in a replica of its original Riverview pavilion. It is the only element at Six Flags Over Georgia to be listed on the National Register of Historic Places. (Nelson Boyd collection.)

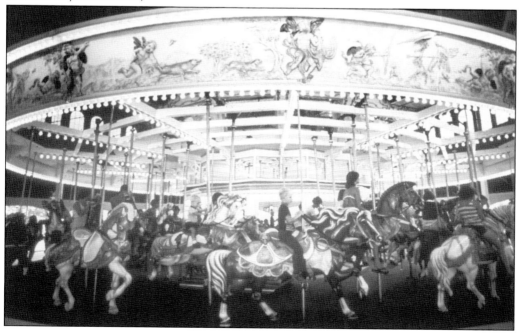

General manager Errol McKoy had first suggested that Six Flags install a classic wooden roller coaster as far back as 1969, but Angus Wynne was cool to the idea. By 1971, things had changed, and McKoy staked his career on the success of his dream: the Great American Scream Machine, which would debut in 1973. (Six Flags collection.)

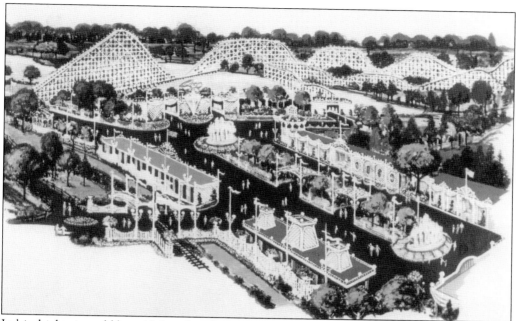

In hindsight, it could be said that the advent of the Riverview carousel in 1972 was the "coming attractions trailer" for the park's newest section, the Cotton States Exposition, which was meant to capture the feeling of an entire c. 1902 amusement park. (Andy Duckett collection.)

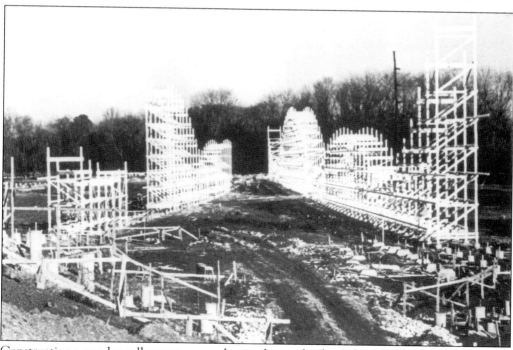

Constructing a wooden roller coaster was almost a lost art by the early 1970s, but Six Flags enlisted the help of legendary coaster designer John Allen and the Philadelphia Toboggan Company, which had been building such thrill rides since the 1880s. (Six Flags collection.)

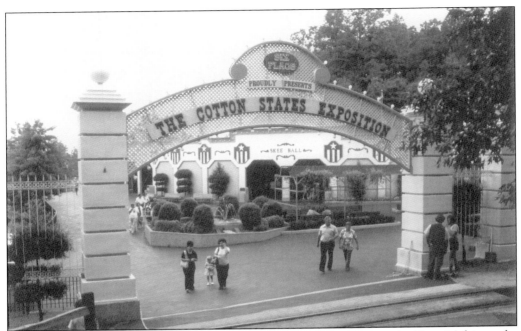

When the Cotton States section opened in 1973, it was given its context in Georgia's history by being loosely modeled after an actual world's fair–type exposition that had been held in Atlanta in 1895. (Andy Duckett collection.)

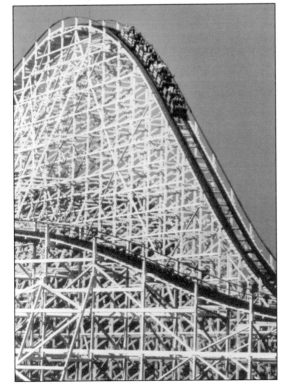

It is unlikely that anything resembling the Great American Scream Machine existed at the 1895 Cotton States Exposition, but that didn't keep the 1973 version from reviving public interest in the genre of the wooden coaster. Soon amusement parks across the country were having their own versions constructed. (Andy Duckett collection.)

You won't often find a more classic example of the 1973 style of commercial art, heavily influenced by *Yellow Submarine* and Peter Max, than this promotional piece. Notice the coaster's original logo, a screaming Uncle Sam, on the front of the car. (Author's collection.)

While waiting in line for some of the Cotton States rides, guests were entertained by a unique offshoot of puppetry known as Aniforms. Puppeteers used rods to manipulate the white-against-black figure seen here, and the image would be projected on a TV monitor in negative form (black lines against a white background). The microphone enabled one puppeteer to provide a voice and carry on a conversation with the waiting guests. (Six Flags collection.)

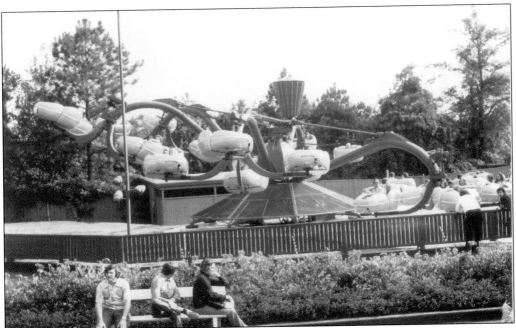

MoMo the Monster was an alien invader into the Cotton States section; it had been writhing its tentacles in the U.S.A. section since 1974 but was eventually picked up and moved bodily to the area where the other classic amusement rides could be found. (Andy Duckett collection.)

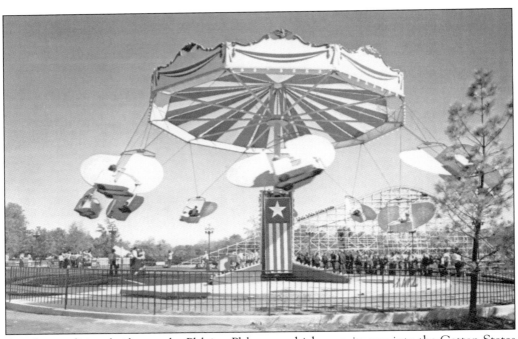

Another traditional ride was the Phlying Phlurpus, which spun its way into the Cotton States section in 1974. (Wayne Neuwirth collection.)

In the shadow of the Great American Scream Machine, Mr. Bear and Mr. Rabbit were joined by British characters known as the Wombles when they celebrated the park's 10th anniversary in 1977. (Six Flags collection.)

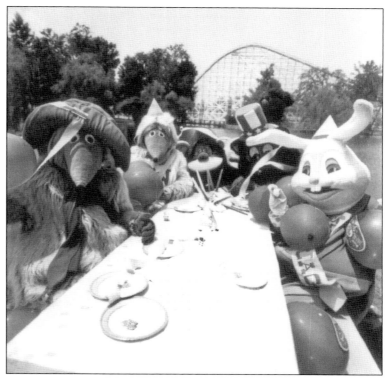

Tissue flowers were a popular souvenir item in the late 1970s. Guests seemed to enjoy watching them being made as much as actually taking the colorful creations home. (Author's collection.)

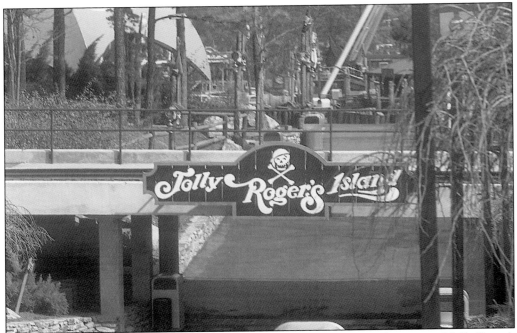

After adding no new sections to the park for seven years, in 1980, Six Flags opened Jolly Roger's Island. Its nautical/pirate theme had only the slightest tie to Georgia history—primarily the seaports around Savannah and Jekyll Island—but buccaneers of all flags were welcome. The main ride (below) was the Flying Dutchman rocking ship. (Six Flags collection.)

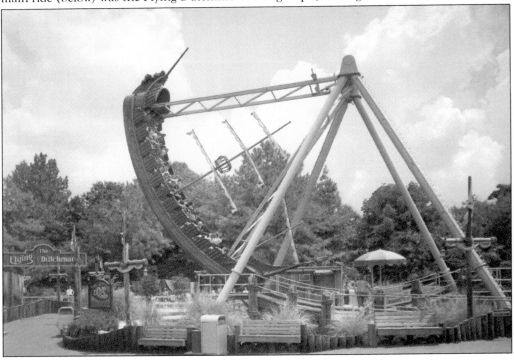

Ten

AN UNFLAGGING PUBLICITY CAMPAIGN

As with any other business, a theme park depends on advertising and promotion to let the public know it is there. Even a well-established place such as Six Flags has to constantly keep its name and image in front of the public, reminding them of the fun to be had. In this final section, we will peek in at some of the ways the park advertised itself through the years.

Tourist attractions have a unique advantage over other, more mundane businesses in that they unload truckloads of souvenirs to their customers. Each and every piece that goes home with a guest becomes a miniature advertisement for the park. Every conceivable type of doodad could be purchased in the many Six Flags shops. T-shirts with the official logo were popular sellers, as were sets of the six flags in miniature. The GAF Corporation issued at least two different sets of View-Master reels; one set was undated and titled simply "Six Flags Over Georgia," while the other carried a 1972 copyright date and was subtitled "Day and Night Scenes." It is known that the Dexter company made not only its usual sets of souvenir slides (on cheap film stock that tended to turn red after a few years), but also pre-prepared 8-mm home movies of the park.

In the early 1970s, Six Flags marketed a coloring book that depicted the park's rides being sampled by the Krofft television characters, who were then roaming the property in costumed form. In the early 1980s, a Monster Plantation coloring book and accompanying set of postcards were sold, along with many other types of merchandise to promote the new attraction.

Seeing the evolving styles of brochures the park has used over the years is a lesson in changing advertising methods. Unfortunately few photographs or other examples have survived to show the billboards that once lined I-20 and the other major arteries leading into Atlanta; one design from the early 1970s spelled out the Six Flags name with a different park element forming the shape of each letter—H. R. Pufnstuf for the I, a railroad crossing sign for the X, and so on. While it would be great to have samples of all of these items, the ones in this section do their own good job of illustrating Six Flags' publicity over the past four decades.

Contests to win trips to Six Flags were always popular events for businesses wishing to attract attention to themselves. This poster may date from the very first year of operation, to judge from the attractions pictured on it. (Six Flags collection.)

The park's art staff created these Coney Island–style photo opportunity boards for guests to have their heads inserted into various park scenes. Each time someone showed one of these photographs to a friend, it became another commercial for Six Flags. (Carl Marquardt collection.)

This ashtray, hand-painted in Japan, must surely have been one of the earliest souvenirs crafted for the park. Look back at page 10, and notice that this piece features a variation of the same artwork that adorned Randall Duell's original "Georgia Flags" design for Angus Wynne. (Author's collection.)

The first year's (1967) brochure (left) featured no photographs other than this cover shot of the Log Flume, leading one to speculate that the photograph was actually from Texas. The 1969 brochure on the right was getting thoroughly modern with this stocking-clad little miss. Who could resist that year's slogan: "Whatever you like best, that's what Six Flags is." (Author's collection.)

The 1972 brochure on the left preferred the minimalist approach; the interior prominently featured the new attraction for that year, the Riverview Carousel. The 1973 brochure (right) obviously came at the height of Sid and Marty Krofft's popularity. They would depart Six Flags after the next season to open their own ill-fated amusement park in downtown Atlanta. (Author's collection.)

SOUVENIRS *from* SIX FLAGS
O V E R G E O R G I A

#678-G
SIX FLAGS Over Georgia
Tee Shirt
Sizes 4 through 14 $1.00 each

#125-G
Set of six silk flags in
wooden base.
Flags are 5 x 7 inches and include
United States, Georgia, Spanish,
French, British and Confederate
flags, which fit in wooden stand.
$1.50 per set

#804-G
Plastic ash tray and coaster set
8 coasters & 4 ash trays in gift box.
$2.49 per set
Also available in coasters only,
4 for $1.00

#G-475S in Sterling Silver
#G-475G in 10K Gold Filled
Round Cloisonne Charm
Of SIX FLAGS
$2.49 each

#301-G
Sterling Silver
Collector's Spoon
Bowl Shows SIX FLAGS, Seal of
Georgia on handle.
$3.00 each

#304-G
Cloisonne Charm
Map of Georgia with SIX FLAGS
Over Georgia in full color. Avail-
able in 10K Gold Filled or in
Sterling Silver.
$2.49 each

#644-G
Set of 4 Coasters
$1.00 per set

REEL 1 #9214-1G

REEL 2 #9214-2G

8MM COLOR FILMS OF SIX FLAGS
Silent, Color Film. Each 50 foot reel contains scenes of
major rides, shows and attractions in the Park.
Reel 1 includes entrance mall, the Georgia, Confederate
and Spanish sections. Reel 2 includes British, U.S.A. and
French sections. By splicing both reels together, a com-
plete motion picture tour of the Park lasting 6 minutes
can be enjoyed.
Each reel is $6.95 REELS 1 & 2 for $13.90

The Six Flags souvenir line of the early 1970s might seem a bit limited by today's standards, but just try to imagine what any of these items would bring on the eBay collectors' market today. Probably the most rare of all are the 8-mm color films in the lower right hand corner; just try finding those for $6.95 now. (Author's collection.)

The previous page showed a sampling of early souvenirs, but this amazing shot of one of the park's shops in 1969 is enough to make any tourism memorabilia collector hyperventilate. If you have shelled out money to buy this book, you quite likely still have some of these items in your own attic or garage. Start looking! (Six Flags collection.)

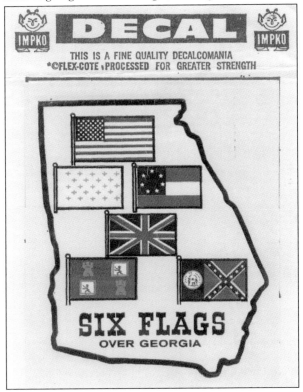

Souvenirs did not have to be expensive to possess their own appeal. These stick-on decals from the Impko company were produced for practically every major and minor tourist attraction in the country and are highly sought after today because of their disposable nature. (Author's collection.)

In keeping with the idea of sending advertisements home with the guests, even the paper bags used in the gift shops were emblazoned with graphics of the park's major attractions. (Donnie Pitchford collection.)

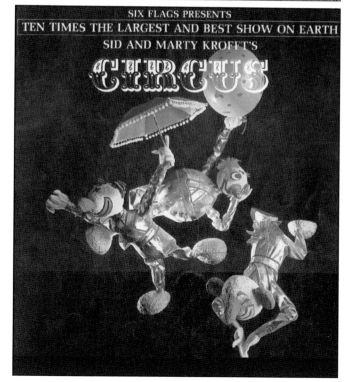

The souvenir booklet from the first Krofft puppet production for Six Flags, 1967's *Circus*, pictured many of the puppets used in the show and featured Sid and Marty's biographies, just prior to their national fame as children's television program producers. (Donnie Pitchford collection.)

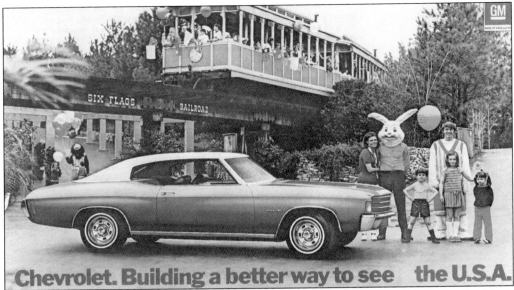

There seems to be a problem with this 1972 Chevrolet advertisement photographed at Six Flags. Take a close look at the family on the right: Mr. Rabbit's body has a human head protruding from the top, yet the "father" of this family has the head of a giant rabbit. The "mother" and her kids are obviously content with being a bunny's brood, while at far left, Mr. Bear gives out balloons and pretends not to notice what is going on. The advertising world could be weird. (Author's collection.)

For some reason, images showing Six Flags' many billboards are rare, but these examples were captured in 1974 by park employee and avid photographer Andy Duckett. The bottom one promoted the second season for the Great American Scream Machine. (Andy Duckett collection.)

Dignitaries of all stripes were given the red carpet treatment when they visited Six Flags. Here diplomats from the Living Island and Lidsville embassies get chummy with then-governor (and future president) Jimmy Carter in 1974. (Six Flags collection.)

When Tony Orlando and Dawn made a personal appearance at the park, they went for a ride on the Great American Scream Machine. Here the ladies appear to be reassuring Orlando that if he doesn't make it back, they will gladly tie a yellow ribbon around some old oak tree. (Six Flags collection.)

One of the rarest of all Six Flags collectibles is this coloring/activity book picturing Pufnstuf, Cling and Clang, and the Lidsville gang enjoying the park's attractions. If you have one, count yourself lucky! (www. WorldofKrofft.com collection.)

Cultivating its relationship with local elementary schools, Six Flags sent Pufnstuf out to meet the kiddies in person during the 1973–1974 school year. (Shaunnon Drake collection.)

SIX FLAGS

I-20 W OVER GEORGIA ATLANTA

Many cars sported these yellow-and-black bumper stickers when they pulled out of the parking lot after a day's fun. Sometimes this was unintentional on the driver's part; the rules required that one leave their sun visor down if they did not wish to have a sticker attached to their car. Any autos with visors up were fair game. (Author's collection.)

This record album was produced for Six Flags and sold in the park in 1973. It featured songs about the different rides and attractions, sung in the styles of various popular performers. For example, a Johnny Cash soundalike sang the song about the Six Flags Railroad. (Author's collection.)

Six Flags' annual press kits always featured striking covers. The 1973 edition highlighted these six airbrushed gems to represent each of the original flags. (Nelson Boyd collection.)

The press kit shown above would have been distributed at this Six Flags booth at an unidentified trade show. The signs announce that Pufnstuf and Rah Rah the football helmet would be putting in a special appearance at the booth as well. (Nelson Boyd collection.)

It's too bad the 1976 press kit can't be shown in color, as its yellow and orange stripes are real eye-poppers. Obviously the big news that year was the debut of the Great Gasp. (Andy Duckett collection.)

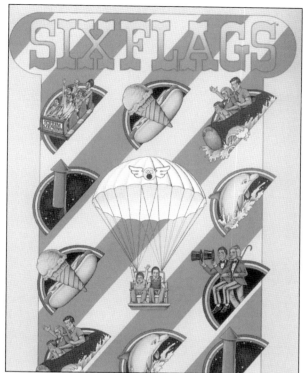

It was also in 1976 that CBS crews invaded Six Flags to tape an episode of *Captain Kangaroo*. Baby boomers should gladly chuckle along with this priceless behind-the-scenes shot, as Mr. Moose once again tricks the gullible captain into a shower of Ping-Pong balls. (Six Flags collection.)

More than any other prior attraction, the debut of the Monster Plantation in 1981 was accompanied by an entire line of tie-in toys and merchandise. A whole new souvenir shop, the MonStore (seen in the inset photograph), was constructed to handle it exclusively. (Gary Goddard collection.)

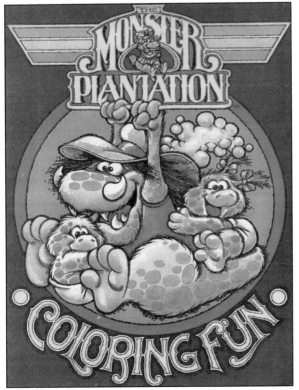

Cartoonist Dennis Jones outdid himself with the illustrations for this Monster Plantation coloring book, which was one of the few places where one could actually find the names of all of the mansion's goofy residents. (Larry Nikolai collection.)

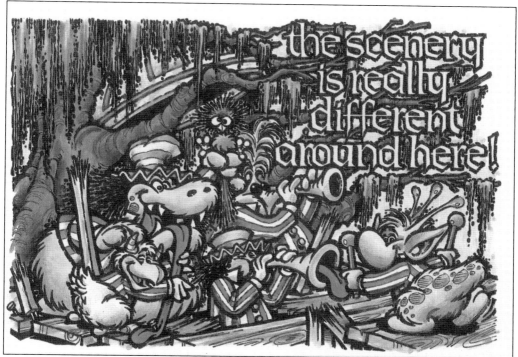

Dennis Jones also created a line of Monster Plantation greeting cards, including this one highlighting the ride's resident Dixieland band, the Lagoon Goons. (Dan Alexander collection.)

Six Flags had a long-standing tradition of displaying beautiful movie-style posters for each of the attractions in the park. Most have vanished without a trace, but this Monster Plantation monsterpiece—er, masterpiece—is a good example of their style. (Gary Goddard collection.)

The 1982 brochure at far left naturally enough promoted the new Thunder River, which had taken the place of Jean Ribaut's Adventure that season. On the right, 1985 marked the introduction of Bugs Bunny and the Looney Tunes loonies into Six Flags. (Author's collection.)

This impressive three-fold spread appeared in the 1984 brochure, highlighting the new Great Six Flags Air Racer ride. Notice that Hallmark Cards' costumed Shirt Tales characters were holding down the fort until Bugs and his friends could move into town the next year. (Author's collection.)

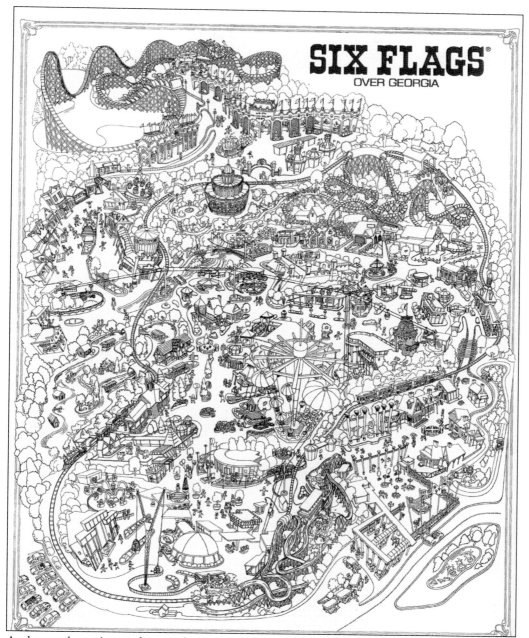

And now, class, it's time for your final exam. Above you see the original line art for the 1976 Six Flags souvenir map, before the various attraction names were typeset. If you have read this far, you should be able to identify each and every ride and building by yourself. Pencils ready? Get set. Go! And ya'll come back now, y'hear? (Andy Duckett collection.)